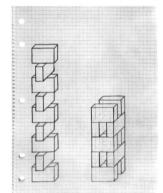

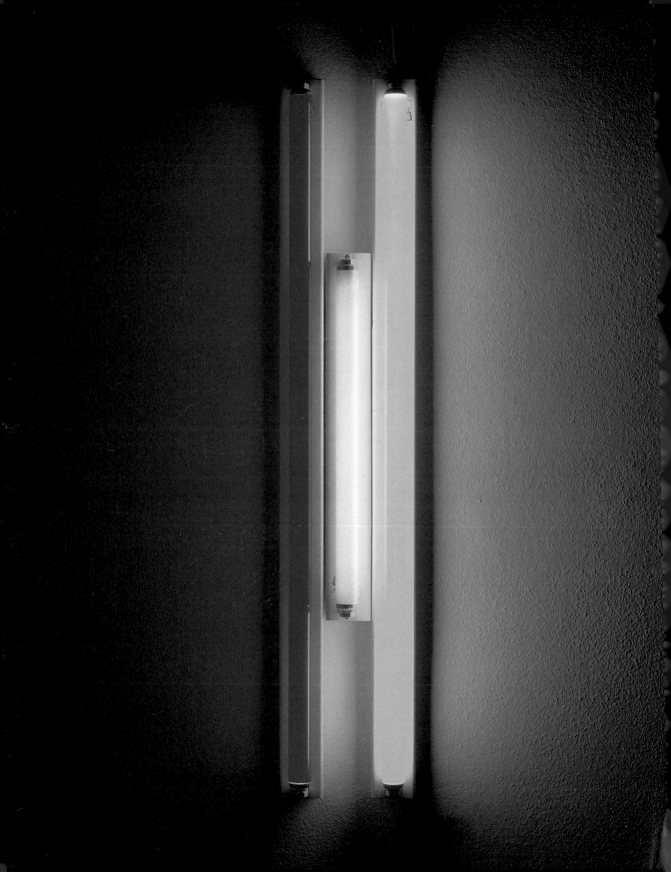

minimal art

DANIEL MARZONA
UTA GROSENICK (ED.)

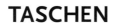

HONG KONG KÖLN LONDON LOS ANGELES MADRID PARIS TOKYO

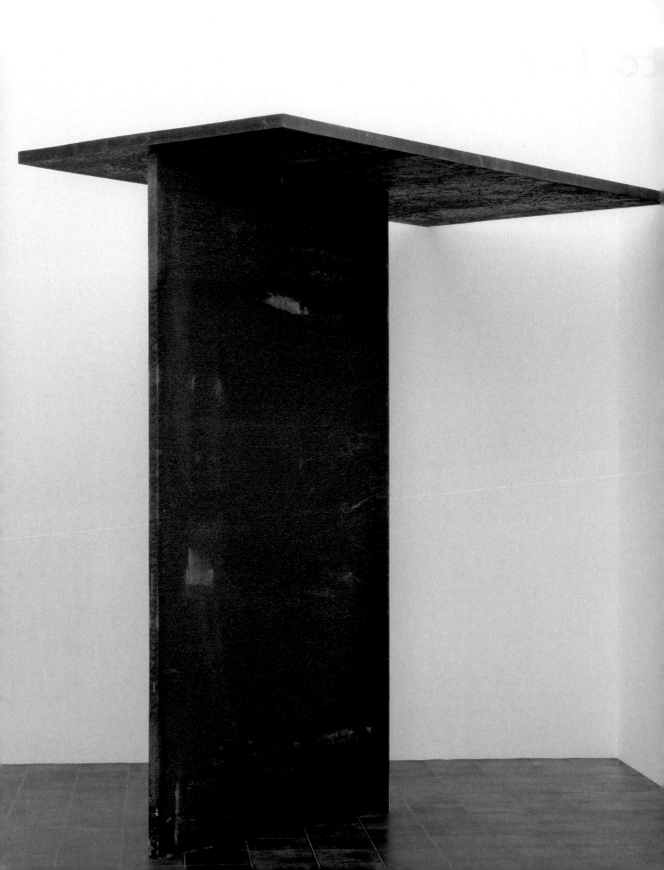

content

"what you see is what you see"

An everyday fluorescent tube fastened diagonally to the wall; rough wooden beams or metal plates laid in simple patterns on the floor; boxes made of metal or Plexiglas placed in simple arrangements; cubes and other basic geometric forms made of plywood, aluminium or steel – these would be some of the ways to describe the works of numerous artists who were active in New York and Los Angeles in the early sixties.

When these "sculptural" works were first put on display in New York galleries in 1963, and a little later in museums, most art critics – not to mention the public at large – were at first totally unprepared for what they saw. The art scene in the American metropolis was at that time still fairly easy to follow: Pop Art was celebrating a triumphal march – at least from the commercial point of view – and, in the form of a major exhibition at the Museum of Modern Art, was at last being consecrated by the high priests of modern art. Otherwise the dominant trends were still the partly abstract, partly figurative painting of the Abstract Expressionists, and what was known as Post-Painterly Abstraction.

The confusion brought about by the seemingly unassuming objects that now burst on to the American art scene is clear enough from the variety of terms used by the critics when seeking to describe the "new works" of this hard-to-understand phenomenon: ABC Art, Cool Art, Rejective Art, Primary Structures, Literalist Art were some of the most prevalent. Ultimately they settled on Minimal Art, which was first used by the English art-philosopher Richard Wollheim in 1965. It is however remarkable that Wollheim, in his essay entitled *Minimal Art*, when illustrating his thesis that a minimalization of artistic content had been apparent in numerous works over the previous fifty years, did not adduce as an example a single one of the artists who were soon to be lumped together under precisely this description. Wollheim's analysis is concerned rather with the Neo-Dadaists, with Ad Reinhardt and most of all with the ready-mades of Marcel Duchamp.

Unlike the term Minimalism, which is used to describe corresponding tendencies that have taken place in dance, music, literature, painting and sculpture since the early fifties, the description Minimal Art is confined to the visual arts. Painting is assigned a pioneering role in Minimal Art, since the significance of the movement lies in the argument concerning the status of abstraction in the field of three-dimensional objects (or "sculpture", as some artists persisted in calling it). Although there are painters who must be considered very close to Minimal Art (for example, Jo Baer, Robert Mangold, Agnes Martin,

1955 — Signing of the Warsaw Pact 1955 — West Germany joins NATO 1955 — First "documenta" exhibition of modern art held in Kassel 1955 — Billy Wilder makes the film "The Seven-Year Itch" 1955 — Withdrawal of French troops from Vietnam

1. FRANK STELLA

<u>Die Fahne Hoch</u>
1959, lacquer on canvas, 309 x 185 cm
New York, Whitney Museum of American Art

2. CARL ANDRE

<u>Pyramid</u>
1959, original destroyed, reconstructed 1970, wood,
74 pieces, 175 x 79 x 79 cm
Dallas, Dallas Museum of Art, General Acquisitions
Fund and matching funds from The 500

1 2

Robert Ryman), from a historical point of view, the movement is one that programmatically transcends painting.

In the strict sense, there are only five artists whose objects, sculptures, and installations can be subsumed under the term Minimal Art: Carl Andre, Dan Flavin, Donald Judd, Sol LeWitt und Robert Morris. On the one hand, the discourse on the artistic movement which later became known as Minimal Art took shape largely in the course of confrontation with the works of these artists, while on the other, it was precisely they, Donald Judd and Robert Morris above all, who first staked out and largely determined the theoretical foundations of the movement.

Another noteworthy aspect is that none of these artists ever agreed to being labelled a "Minimal Artist". Small wonder, therefore, that even today there is no adequate definition of what should be understood by the term, theoretically or aesthetically.

Hitherto, most attempts at defining Minimal Art have been based primarily on an analysis of shared formal features, for example, a reduced formal vocabulary, serialism, non-relational compositional techniques, the use of novel, industrially-produced materials and industrial production processes. However, no comprehensive understanding of Minimal Art is possible without an analysis of the substan-

tial changes that took place between 1945 and 1968, changes that affected not only the way art as such was seen, but also its social status and its accessibility through the media.

Historical Preconditions for Minimal Art – in Painting

It is one of the strangest facts in recent art history that important foundations for the appearance of Minimal Art were developed and implemented in the field not of sculpture but of painting. After all, it was Minimal Art, which, after Russian Constructivism and the Bauhaus of the twenties, once again seriously challenged the supremacy of painting within modern art.

While in the field of sculpture innovations had only slowly become apparent before 1960 (until then most three-dimensional visual art could be related more or less to the structure of Cubist sculpture), the development of American painting took a breathtaking turn after the end of the Second World War. The naive-idyllic glorification of American rural life, as portrayed by, for example, Grant Wood or Thomas Hart Benton, and highly regarded before the war, now lost steam, while avant-garde painting was clearly tending towards

1955 — Death of the physicist Albert Einstein **1956 — Death of Jackson Pollock in a car accident**
1956 — Suez crisis: Britain, France and Israel attack Egypt **1957 — Soviet Union launches the world's first satellite Sputnik I**

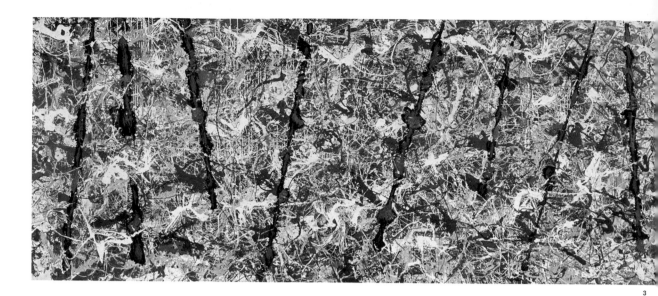

large-format abstraction. Jackson Pollock (1912–1956) created his first "drip paintings" in 1947. A year later came the first "zip painting" by Barnett Newman (1905–1970), and in 1949 Mark Rothko (1893–1970) painted his first hovering colour field. From the American point of view, the work of these artists had already clearly emancipated itself, in the formal sense, from the European tradition. Even though these paintings could still be seen as subjective colour spaces reflecting the artist's expressive will, at the same time they really did reject traditional techniques of composition.

When these works were created in the late forties, there was no theoretical framework by which their worth could be judged, so that an appropriate critical language had to be developed in parallel. It was to fall to the art-critic Clement Greenberg and a few others, including Harold Rosenberg and Meyer Schapiro, to provide, in numerous essays, the theoretical foundation for these novel forms of abstraction. While Harold Rosenberg focused his attention on the creative act with all its effects in relation to the artist's subjective state, Clement Greenberg argued on a strictly formalistic plane. The immediacy of the new pictures aroused his enthusiasm from the start, and within a few years he had developed one of the most influential theories of modern art, in particular modern painting. During the fifties,

his theory, which quickly came to dominate the way in which American abstraction was received, along with his regularly published reviews made a major contribution to the success of particular positions in painting. For many of the Minimal artists, Greenberg's theory served as the starting point and matrix of a critical investigation.

In unmistakable affinity to the epistemological theory of the German philosopher Immanuel Kant (1724–1804), Greenberg maintained the opinion that it was the responsibility of every artistic genre to subject its own elemental conditions to critical questioning, in order thus to develop its essential features. The "all-over" concept – a flat picture-surface to which paint, reaching to the borders of the canvas, has been evenly applied, thus not emphasizing any one part of the picture while at the same time flattening the pictorial space – seemed to him best suited to revealing the "essence" of painting. Illusionism was to be avoided if at all possible, and figurative painting was to be seen *a priori* as relatively inadequate.

The purely formal arguments employed by Greenberg were later to become an important target of Minimalist criticism. However, the rupture between Minimal Art and modern art à la Greenberg came about rather as a result of the Minimal artists' rejection of the normative character of his aesthetic and his somewhat rudimentary recep-

1957 — In the USA federal troops enforce racial integration in public schools 1957 — Britain announces it has the hydrogen bomb
1958 — Fifth Republic inaugurated in France under General Charles de Gaulle 1958 — "EXPO 58" world fair in Brussels

JACKSON POLLOCK
Blue Poles
1953, oil, lacquer and aluminium paint on canvas,
2.11 x 4.89 m
Canberra, Australian National Gallery

JASPER JOHNS
Flag
1954/55, encaustic, oil, collage on cloth,
mounted on plywood, 108 x 154 cm
New York, The Museum of Modern Art, Gift of
Philip Johnson in honour of Alfred H. Barr, jr.

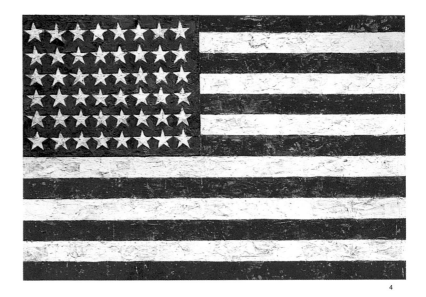

4

on theory, which seemed to assume that in some inexplicable fashion, works of art emanated a significance that could only be understood intuitively by just a few initiates in a context divorced from the constraints of time and space.

The Picture as object

Jasper Johns (b. 1930) and Robert Rauschenberg (b. 1925) were among the first artists, who, with their fifties works, challenged the various forms of Abstract Expressionism. Rauschenberg's *Combines* and Johns' *Targets* and *Flag Paintings* bore witness to a new way of thinking about pictures. In these figurative works, the painting was accorded the status of an object that shared the beholder's space. Instead of looking into the picture, or being embraced and overwhelmed by a large-format expanse of colour, the viewer was constrained to look at the surface of a flat picture. In addition, Johns' works at least could no longer be interpreted as the expression of the artist's emotional or psychological state. In his painterly appropriation of the "ready-made" strategy formulated by Marcel Duchamp (1887–1968), Johns emphasized the separation between the work

on the one hand, and the subjective artist on the other. An admittedly somewhat eccentric and abbreviated reading of Duchamp's ready-mades had led him to the insight that the famous *Bottle Dryer*, which Duchamp selected in a Paris department store in 1914 and declared to be a work of art, could say little about the emotional state of the artist, who had after all only selected it, and not created it himself. In analogous fashion, and in the spirit of this logic, the ready-made motifs used by Johns in his painting were intended to undermine the need for self-expression on the part of the artist.

In the late fifties painters such as Kenneth Noland (b. 1924) and Frank Stella (b. 1936) began to radicalize the ideas developed by Johns in the field of abstract painting. In 1958/59 there appeared a series of pictures that were to play an important role in the development of Minimal Art. Frank Stella, who at this time shared his studio with Carl Andre, was working on his *Black Paintings*, which in their simplicity and lack of expressivity consistently ignored traditional questions of painterly composition. Stella used a house-painter's brush and commercial enamel paints to create black stripes of identical width which evenly covered the whole pictorial space in a graphic pattern laid down precisely before he started. In the narrow spaces between the stripes, the unpainted canvas remained visible, as did the

1958 — Playwright Samuel Beckett publishes "Endgame" 1958 — Mies van der Rohe builds Seagram Building in New York
1959 — Boeing 707 jet airliner reduces flight time from Paris to New York to eight hours

9

5

guidelines drawn with pencil and ruler. In this way, Stella developed what he called a non-relational design principle, which he declared to be elementally American, and which he set up in opposition to the European painting tradition. By stretching his canvases on supports a few centimetres broader and dispensing with a frame, Stella seemed in addition to emphasize the sculptural aspect of his pictures. This tendency was reinforced in the *Shaped Canvases* which appeared between 1960 and 1962, in which the internal structure of the picture often coincided completely with the shape of the support, and indeed seemed to be derived from it.

These early pictures by Stella are so important for the development of Minimal Art because on the formal plane, they anticipate features which a few years later were to return in the three-dimensional objects of the Minimalists, such as the use of materials and production techniques hitherto unknown to art, and a meticulous plan laid down before the execution of the work, leaving little room for chance during the implementation stage. In addition – and this is perhaps still more important – in his works Stella radicalized the anti-illusionist tendencies within American painting to an almost unsurpassable extent by totally flattening the pictorial space, displaying its object-like character for all to see, and rejecting *a priori* any referentiality in the depic-

tion. "What you see is what you see," was the famous tautology in which Stella summed up his concerns as a painter.

Although central aspects of Minimal Art in the late forties and fifties were pioneered in painting rather than sculpture, this does not mean that in Minimal Art a purely American painting tradition in the sense of an anti-subjectivist reduction process was simply taken up and continued seamlessly in the field of sculpture. That recourse was made to the path taken by American painting after the end of the Second World War may well be a sign of the cultural climate, and it may make certain intellectual associations clear, but the pedigree of Minimal Art cannot be derived so simply as this. The assertion that Minimal Art had adopted formal elements of Abstract Expressionism and its successors and merely subjected the aesthetic otheoretical superstructure to a revaluation is an unacceptable simplification. Among other things, it passes over the fact that with Minimal Art, the traditional view of sculpture and painting as narrowly defined genre concepts was subjected to a thoroughgoing examination.

The idea of the picture as object seemed to have run through all its potential fairly quickly, and thus played out, for many artists soon lost its charms. In about 1963, Dan Flavin, Donald Judd and So

1959 — German novelist Günter Grass writes "The Tin Drum" 1959 — French Nouvelle vague film director Jean-Luc Godard
makes "Breathless" 1960 — Start of ten-power disarmament conference in Geneva; East and West reject each other's proposals

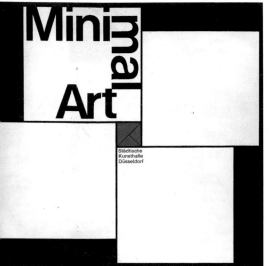

Städtische
Kunsthalle
Düsseldorf

6

"Half or more of
the best work in the
last few years has
been neither painting
nor sculpture."

Donald Judd

5. BARNETT NEWMAN

<u>Vir Heroicus Sublimis</u>
1950/51, oil on canvas, 242.2 x 513.6 cm
New York, The Museum of Modern Art,
Gift of Mr. and Mrs. Ben Heller

6.

<u>Minimal Art</u>
Exhibition catalogue Kunsthalle Düsseldorf, 1969

eWitt turned away from painting to concentrate on working on and with objects in real space. This movement away from the wall into the room gave rise to an art that could no longer be harmonized with the traditional conventions of Modernism. For while painting, because of its multiple ambiguous pictorial space and inevitable illusionism, was rejected and abandoned as being ultimately inadequate, Minimal Art rejected the foundations of modern sculpture perhaps even more clearly. The three-dimensional works of Andre, Flavin, Judd, LeWitt and Morris refer neither metaphorically nor symbolically to anything beyond themselves, and can no longer be translated back into anything pictorial.

By emphatically concentrating on the concrete experience and perception of the work in question in its specific context, Minimal Art rejected a metaphysics of art and thus not least changed the role of the beholder, who was no longer required, in an act of silent contemplation, to reflect on the unchanging significance of the work of art hanging or standing in front of him, but rather to actively perceive the work which was sharing his space, to reflect on the process of this perception, thereby charging it with significance.

upheavals – Transformations of the object

Although the five central artists of Minimal Art are all part of the same generation, and have all without exception lived in New York at the latest since the early sixties, they have executed their respective œuvres in relative independence one of another and on the basis of undoubtedly different preconditions and positions. Their artistic approaches, if compared on formal and conceptual planes, at once evince at least as many differences as similarities, and can be clearly demarcated one from another.

In what follows, we shall discuss the early development of each artist until about 1968. This was the year that witnessed the opening of the touring "Minimal Art" exhibition curated by Enno Develing for the Gemeentemuseum in The Hague, which shortly afterwards was also to be seen in Düsseldorf and Berlin. In the USA, Minimal Art was already established by this date, and was undergoing its first assaults, which were not long in coming in Europe either, albeit from a different perspective. With respect to Minimal Art, the year 1968 can be seen as a twofold historical caesura. On the one hand, it established itself as a museum-worthy movement in Europe too, and on the other, the artists generally assigned to it had by then either fully

1960 — German architect Hans Scharoun builds the Philharmonie in Berlin 1960 — Brazilian architect Oscar
Niemeyer starts building the new Brazilian capital Brasilia 1960 — Alfred Hitchcock makes the film "Psycho"

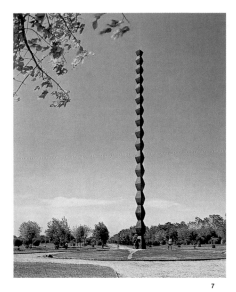
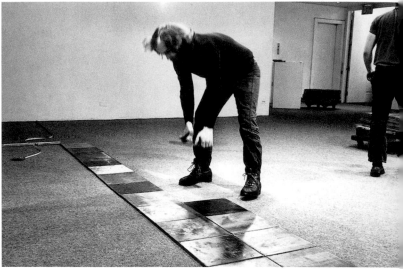

7

"art is what we do.
culture is what is done to us."

Carl Andre

developed the foundations of their work or else abandoned the Minimalist discourse.

carl andre

It is true that Carl Andre has always emphasized the importance of Frank Stella's *Black Paintings* for his own work, but unlike that of most of the artists normally reckoned as working within Minimal Art, his early work did not develop primarily as part of a critical confrontation with painting. He was concerned with the sculptural tradition, taking an interest above all in the work of the Romanian sculptor Constantin Brancusi (1876–1957) and later the pioneering work of the Russian Constructivists. It was for this reason that, alone among the Minimal artists, he retained, without any ifs or buts, the term "sculpture" for his own work.

After moving to New York in 1956, Andre spent the years up to 1959 on relatively shifting sands, working as a poet, the author of dramatic short stories, a draughtsman, and the designer of mysterious small sculptures of Plexiglas and other, mostly found, materials. In 1958 he met Frank Stella, and from then on, Andre concentrated first

and foremost on sculpture. There quickly developed a close friendshi[p] between the two artists, and soon they were sharing Stella's studio o[n] West Broadway. This was the birthplace of Andre's first two larg[e] sculptures, *Last Ladder* (1959) and *Pyramid* (1959). While *Last Lad- der*, formed from a wooden beam, unambiguously points in its repeti- tive structure and form to an intense interest in Brancusi's sculptur[e] in particular his *Endless Column* dating from 1937/38, *Pyramid* b[y] contrast already seems to reflect the lasting influence of Stella's pic- tures. The two pyramids, placed one on top of the other apex-to-ape[x] are derived from identical wooden beams, and represent a transfer [of] Stella's modular technique to sculpture. The individual components [of] *Pyramid* were not worked by Andre to give them further shape[,] but unlike all his later works, they are fitted into each other, and thu[s] connected.

In 1960 Andre, with the *Element Series*, conceived a group [of] works which already exhibit important aspects of his mature œuvr[e.] As in the early sixties Andre did not have the money to execute hi[s] concept; the *Element Series* existed for more than a decade as n[o] more than a series of pencil drawings on squared paper: differen[t] configurations of identical rectangles. Only in the early seventies wa[s] Andre able to execute eight selected concepts. Identical, industrially

1960 — The Nouveau Réalisme art movement appears in France
1961 — Democrat John F. Kennedy becomes President of the USA
1961 — Writer Ernest Hemingway commits suicide
1961 — East Germany starts building the Berlin Wall on 13 Augus[t]

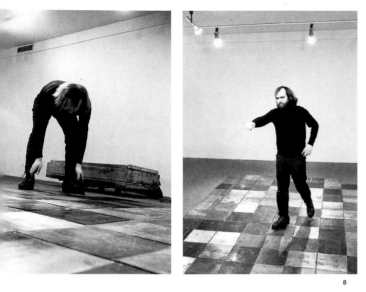

7. CONSTANTIN BRANCUSI

<u>The endless column</u>
1937/38, cast iron and steel, height 29.35 m
Tirgu Jiu, Romania

8.
Carl Andre during the installation of his exhibition
at the Dwan Gallery, New York 1969

8

roduced blocks of wood are combined into simple structures, the individual elements being held in place by the force of gravity alone. The spectrum of sculptures belonging to the *Element Series* ranges from *Herm*, a single vertically upright beam, via *Inverted Tau*, an inverted T formed of two beams, to *Pyre*, a cuboid consisting of eight blocks placed one on top of the other.

With the use of prefabricated materials, the unconnected (Andre's term was "clastic") arrangement of individual identical elements within each work, and the limitation to relatively simple basic shapes, the *Element Series*, conceived in 1960, already evinces three important characteristics which we find in Andre's work to this day. Two others were added in the mid-sixties. In 1966 Andre displayed *Lever* in the "Primary Structures" exhibition. This consisted of a line, nearly nine metres in length and with one end against a wall, of 137 beige bricks, placed with their long sides juxtaposed. Designed specially for the exhibition site, *Lever* was the first of Andre's sculptures to relate unambiguously to the floor, and to emanate its effect from the floor into the exhibition room. The same year, Andre incorporated the entire floor of the Tibor de Nagy Gallery in New York as an integral part of the *Equivalent Series*. Eight different formations of 120 bricks each of two layers one on top of the other covered the floor of the

gallery, the free floor space between the individual structures being no longer perceptibly separable from the work itself.

Since 1967, Andre has used prefabricated thin, mostly square, metal plates, which he has laid out into squares or linear formations, arranged according to simple mathematical principles.

When in 1967, on the occasion of his first European exhibition, "Ontologische Plastik", Andre covered the entire floor of the Konrad Fischer gallery in Düsseldorf with steel plates, many anxious visitors asked where the art actually was. The gallery owner, amused, was forced to point to the floor. The art was beneath their feet, unnoticed. Lying flat on the floor, and with no "Keep Off" signs, these works appear, by taking possession of a site, to have had the entire interior space pressed out of them. The site is thereby redefined. Thus these works are deprived for the first time of a characteristic of modern sculpture hitherto thought to be essential: their volume. Instead, they emphasize both their existence as mass and at the same time the specific qualities of the materials used. These are deployed in ways alien to their standard utilization, and are perceived all the more clearly in consequence. By not forcing the basic materials he uses into their final shapes by such traditional techniques as welding, moulding or carving, Andre expresses his rejection of a concept of sculpture in

1961 — Contraceptive pill comes on to the market 1961 — The Beatles perform in the
amburg "Star Club" 1961 — First Soviet manned space flight: Yuri Gagarin orbits the earth on 12 April

"...my own proposal has become mainly an indoor routine of placing strips of fluorescent light. ɪt has been mislabeled sculpture by people who should know better."

Dan Flavin

9

which the materials are refined. In Carl Andre's work, a particular material remains what it is, and points to nothing beyond itself.

With the use of identical units, Andre also succeeds in avoiding the hierarchy problem of traditional sculpture. For if all the elements in a work are identical, and of equal importance for the generation of its total form, there can no longer be any centre and or any periphery within the work. Further, this observation is in accord with the fact that there is no longer any ideal position from which to view these new sculptures.

Almost always conceived for a particular exhibition situation and mostly installed by the artist himself, the works in metal executed in 1967/68 complete a re-definition of sculpture, one which gradually arises from the work itself, described by Andre as follows: "The course of development: / Sculpture as form / Sculpture as structure / Sculpture as place."

ᴅan ꜰlavin

Dan Flavin's work developed in a far less straightforward manner than that of most of his fellow Minimalists. After he returned to New York in 1956 after military service in Korea, Flavin at first enrolled as a student of art-history at the Hans Hoffman School aɳ the New York School for Social Research. Two years later, he tooᴦ courses in art-history and drawing at Columbia University in New Yorᴋ It was during this period that he made the decision to devote himseᴌ exclusively to art. Between 1958 and 1961, Flavin produced a coɱ prehensive collection of water-colours, Indian-ink drawings, calᴌ graphic poems, and paintings which were all still clearly rooted in thᴇ tradition of Abstract Expressionism. It was above all the gesturᴇ Expressionism of Franz Kline (1910–1962) and Robert Motherweᴌ (1915–1991) that seemed to have left the deepest marks on Flavinᴄ work during these years.

In the winter of 1961, the young artist had worked throuᴦ enough art-historical role models, and in the form of a series ᴄ mysterious wall objects which he called *Icons*, set out for neᴡ pastures. These *Icons* are boxes attached to the wall, mostly painᴛ ed in one colour, to whose sides Flavin fastened various kinds ᴄ lightbulbs and fluorescent tubes. These first experiments with arᴛ ficial light obviously take up what was then the widespread treɳ toward the "picture as object", but at the same time they alreaᴄ point beyond it. For to the extent that the electric light seems to diᴄ solve the shapes of the *Icons* while radiating into the room, some ᴄ

1962 — Cuban crisis
1962 — First US manned space flight
1962 — Death of Marilyn Monroe
1962 — Launch of Telstar, the world's first communications satellite

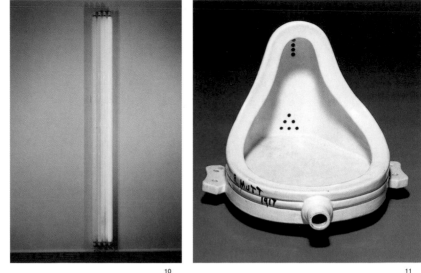

Dan Flavin in his office, 1968

10. DAN FLAVIN
Untitled (to Henri Matisse)
1964, pink, yellow, blue and green fluorescent light,
274 x 25.4 x 12.7 cm
New York, Solomon R. Guggenheim Museum

11. MARCEL DUCHAMP
Fountain
1917/1964, readymade, urinal made of porcelain,
63 x 48 x 36 cm
Private collection

10 11

these works contain within them the potential for room-related installation art.

On May 25, 1963, Flavin experienced his much-quoted artistic breakthrough. It was on this day that he decided to fasten a standard commercial eight-foot fluorescent tube diagonally to the wall of his studio. Immediately enthused by the result and the implications of this operation, the *Diagonal of May 25, 1963 (to Robert Rosenblum)* was for Flavin the foundation stone of one of the simplest and yet most fascinating artistic systems of the second half of the 20th century. From now on, his work developed (if it is possible to talk of a development in this context) using nothing but industrially-produced fluorescent tubes, which he compiled into arrangements of varying complexity.

Flavin's artistic use of readily available existing lighting elements was initially discussed primarily in the context of "ready-mades". This was in accordance with the spirit of the times, as becomes clear when one remembers that the work of Marcel Duchamp was not fully appreciated until a major retrospective at the Pasadena Art Museum (since 1975 the Norton Simon Museum of Art) in 1963; in other words, exactly 50 years after the selection and naming of his first ready-mades. However, the relationship between Flavin's works and

those of the great sceptic of modern art is ultimately superficial. Unlike Duchamp, who in 1917, for example, under the pseudonym of R. Mutt submitted a urinal for an exhibition under the title *Fountain*, in order to draw attention to the questionable nature of any normative definition of art – whereby he stimulated endless reflections on the boundary between art and non-art – Flavin does not use his fluorescent tubes as objects to demonstrate any theory of art. For him, the ready-mades simply serve as formal elements of his art. In Flavin's work, the ready-mades no longer function as a kind of anti-art gesture, but form the starting point and at the same time the exclusive medium of an innovative design process.

After Flavin had exhibited his *Icons* along with a few fluorescent-tube works at the Kaymar Gallery in the spring of 1964, his second solo exhibition in November of that year, at the Green Gallery in New York, already consisted entirely of arrangements of fluorescent tubes, which were distributed around the gallery in a meticulously planned fashion. Works such as *Untitled (to Henri Matisse)* and *A Primary Picture* (both dating from 1964) still seem to be rooted in the pictorial tradition. Flavin soon realized, however, that his system was ideally suited to a relationship between the works and the space in which they were exhibited, allowing perceptions of the latter to be altered.

1963 — Start of the Fluxus art movement in Germany 1963 — First Marcel Duchamp retrospective at the
Pasadena Art Museum (USA) 1963 — Assassination of John F. Kennedy in Dallas, Texas

15

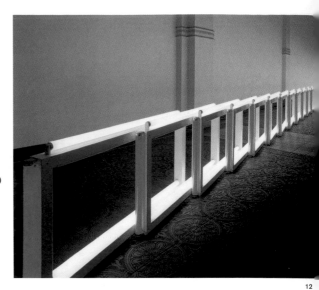

"I knew that the actual space of
a room could be disrupted and played
with by careful, thorough composition
of the illuminating equipment.
For example, if a 244 cm fluorescent lamp
be pressed into a vertical corner,
it can completely eliminate that definite
juncture by physical structure, glare
and doubled shadow."

Dan Flavin

From 1966 onward, Flavin's works became increasingly site-specific and installation-like. He conceived gallery and museum exhibitions consistently to take account of the architectural particularities of the site in question. It is an astonishing experience to see the transformation of an exhibition room in which Flavin has meticulously positioned his different-coloured fluorescent tubes – corners overlap, appear double, or seem to dissolve, whole corridors come across as de-materialized and begin to blur in the reflections of the light, barriers composed of fluorescent tubes sometimes bar access to the room which they illuminate. The use of different colours within separate but interconnecting rooms gives rise to simultaneous contrasts and optical mixtures which allow visitors to perceive what they have only just seen from a marginally different perspective in, metaphorically and also quite literally, an entirely new light.

Flavin's installations not only have their effect on the architecture, they also inexorably integrate the beholder. They no longer put across to the viewer the feeling that he is facing a visible object, but rather that he himself is a light-bathed component of a visually perceivable situation. The decisive moment in this perceptual structure lies not so much in the participation of the beholder, as in the realization that the visible is, on principle, seen not from without, but from within.

Even so, Flavin must not under any circumstances be misunderstood as some light-mystic. For all the obvious difference between them, Flavin shared with the Minimal artists the opinion th a modern work can only represent itself. For this reason, Flavin alwa rejected any metaphysical, let alone mystical, interpretation of h œuvre. Thus he laconically described his works as "proposals" and th fluorescent tubes as "image-objects". The extent to which his proje had moved away from the classical categories of art was expressed more unmistakable terms by Flavin himself than by anyone else: "I fe apart from problems of painting and sculpture but there is no need re-tag me and my part. I have realized that there need not be a subs tute for old orthodoxy anyhow."

Donald Judd

After Donald Judd had completed his military service in Kore in 1947, he moved to New York in 1948, where he first enrolled at th Arts Students League. A year later, he supplemented his study attending courses in art history and philosophy at Columbia Universi It was not until 1962 that he eventually graduated with a maste

1963 — Serious race riots in Birmingham, Alabama

1963 — Swedish film director Ingmar Bergman makes "The Silenc

1963 — Kodak launches first camera with cartridge-loaded film, the "Instamatic"

2. DAN FLAVIN
n Artificial Barrier of Blue, Red and Blue
luorescent Light (to Flavin Starbuck Judd)
968, neon tubes, each 64 x 12.5 cm, length c. 17 m
lew York, Solomon R. Guggenheim Museum,
Collection Panza

3.

xhibition Donald Judd
iew of installation, Whitney Museum of American
rt, New York 1968

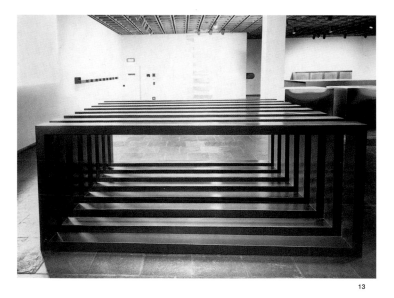

13

egree in Art History, having studied for a total of 15 years with a few
nterruptions.

During the first few years of his academic training, Judd still
ainted conventional landscapes and portraits. Toward the mid-fifties,
is painting became increasingly more abstract, the motifs, such as
ardens and bridges, came across as alienated, but without losing
heir figurative character entirely. 1957 saw the appearance of his first
urely abstract pictures, which he exhibited at the Panoras Gallery in
lew York, and later disparagingly referred to as "half-baked abstrac-
ons". His breakthrough on the road to overcoming any form of illu-
ionism came only in 1961, with pictures that mostly depict simple
ormal elements on a monochrome background.

By mixing his oil-paints with sand and in some cases placing
bjects in a central position on his canvases, he gave additional
mphasis to the surface of his pictures and to their sculptural identity.
1 1962 he produced the first of his mural reliefs, still painted in oils,
ut just a year later he finally abandoned painting in favour of work
ith three-dimensional objects. It is extraordinary that the develop-
ent of his œuvre between 1957 and 1963 took place almost entire-
in camera. For more than five years, Judd refused every offer to
xhibit his works in public. During this period, most New Yorkers with

any interest in art were familiar with the name Judd more as an art
critic than as an artist. His reviews, which appeared regularly from
1959 to 1965 at first in "Art News" and then in "Art International"
and "Arts Magazine", were notorious for the abrasiveness of their
prose style.

In December 1963, the Green Gallery staged Judd's first
solo exhibition, after he had already been involved in group exhib-
itions at the same gallery in the spring of that year. Alongside a few
mural reliefs, Judd exhibited a total of five objects, which were all
placed directly on the floor. Judd had made them all by hand, using
mostly plywood and metal components, and painted them in a uni-
form colour – cadmium red light. The box shape, which he later used
time and again in different versions, was already present here in
two works of almost identical format. On the top of a rectangular
box he had inserted a metal tube, while in the same place on a sec-
ond box semicircular grooves fan out at proportionally increasing
intervals.

The total impression created by the exhibition at the Green
Gallery in respect of material, colour and form was remarkably homo-
geneous, and altogether programmatic. Even at this early stage, it
revealed an irreversible movement away from painting and towards

1964 — Labour government elected in Britain
964 — Formation of the Palestine Liberation Organization (PLO)

1964 — Start of Vietnam War
1964 — Jean-Paul Sartre refuses Nobel Prize

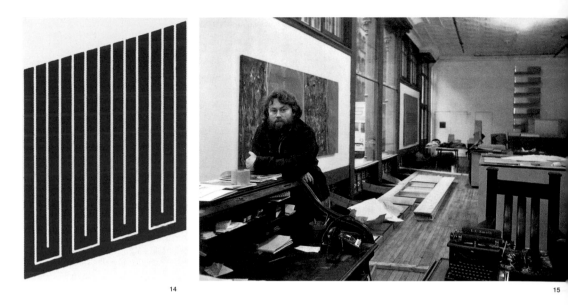

14

15

work in three dimensions, extending into real space. Although clearly derived from painting, the exhibited objects and reliefs bore witness to the fact that Judd's analysis of the conditions of painting led to the conclusion that ultimately this genre was untenably illusionist and naturalistic; this was before he had formulated his ideas on the subject in interviews or in his famous essay "Specific Objects". Instead of suggesting an illusory space, Judd wanted to employ a truly abstract art to use and define real space.

The reaction of the critics was mixed. Brian O'Doherty described the exhibition in the "New York Times" as "an excellent example of 'avant-garde' nonart that tries to achieve meaning by a pretentious lack of meaning", while other critics even claimed to discern figurative references in the objects. But Judd was not deterred, and unperturbed, struck out further along the road towards an art which encompassed space. Not entirely convinced by the look of his handcrafted works, in 1964 he began to exploit the potential of industrial production techniques by commissioning the family firm of Bernstein Brothers to manufacture his objects. From now on, figurative references disappear entirely from his work, leaving an abstract-geometric art of cool elegance, from which all subjectivism, any personal signature, seems to have been exorcized. Various mater-

ials, like differently coloured Plexiglas and a range of metals, ar combined in ever changing variations and forms. Novel proccəsin techniques also enabled him to dispense with painting his object their colour now being an integral element of the respective materia inseparably fused with its surface.

That an artist should use industrial production techniques, i other words transfer the creation of a work of art from the studio to factory, was by no means either usual or generally accepted practic in the mid-sixties. At a podium discussion as late as 1966, the sculp tor Mark Di Suvero could attack Judd, and with him all artists workin in a similar way, with the words "I think that my friend Don Judd can qualify as an artist because he doesn't do the work. But this is no grappling with the essential fact that a man has to make a thing i order to be an artist." The constantly repeated criticism of Minimal Ar namely that it wasn't art, is here linked by Di Suvero not, as so ofte to the fact that there was in it not enough to see, but to the fact tha Minimalist objects were not made by the artists themselves. The tw arguments are related in origin: the absence of an expressive elemer in the work that points to the subjective state of the artist is in bot cases seen as a shortcoming. Judd soon went beyond the simpl made-to-measure tailoring of his objects by starting to exploit th

1965 — Death of the architect Le Corbusier
1965 — Increased US military engagement in Vietnam

1965 — Assassination of the Civil rights activist Malcolm X in New Yor
1965 — Development of the computer programming language Basic

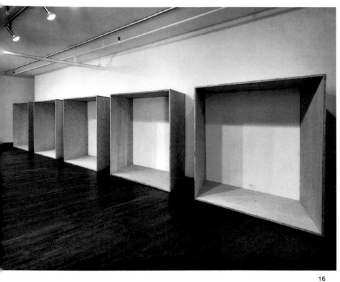

"Yes. The whole's it. The big problem is to maintain the sense of the whole thing."

Donald Judd

14.

Invitation to the exhibition "Graphics"
Leo Castelli Gallery, New York 1968

15.

Donald Judd in his studio, New York 1970

16.

Exhibition Donald Judd
View of installation, Leo Castelli Gallery,
New York 1968

16

possibilities of serial mass production and constructing his works from identical components which at first consisted of simple horizontal rows. 1965 saw the appearance of his first *Stacks*, in which metal boxes were attached to the wall at equal intervals in a vertical column. A little later, Judd had coloured transparent Plexiglas inserted into the tops and bottoms of the metal boxes of his *Stacks*, which made their perception considerably more complicated.

Alongside the multi-component works, between 1964 and 1968 Judd continued to work on one-part monochrome mural reliefs, in which the surfaces reveal projecting elements, the gaps between which get bigger or smaller according to mathematical principles which are not immediately apparent. The — for Judd — essential element of holism in his objects was in his view independent of whether the work consisted of one part or more. As long as there was no element of hierarchical composition or any unnecessary details in a work, it could be put together from a number of components without losing its perceptual unity. Even Judd's early work reveals an amazing variety of design possibilities. It is based not on systems set up *a priori*, but derives rather from a fascination with the unitary apparition of colour, shape, and material in the given space.

Sol LeWitt

Sol LeWitt arrived in New York in 1953 after completing his art studies at Syracuse University with a bachelor's degree and doing his military service in Japan and Korea. In his first few years in the city, he earned his living as a graphic artist, and later as a draughtsman for the architect I. M. Pei. At the end of the 1950s, LeWitt still thought of himself as a painter, and worked in the Abstract Expressionist style.

In 1960 he took a job at the Museum of Modern Art, where he met the artists Dan Flavin, Robert Mangold, Robert Ryman and the critic Lucy R. Lippard, who were also employed there. His artistic work now began to undergo a visible change. In 1961/62 LeWitt developed the first austerely geometric monochrome *Wall Structures,* strange objects of painted wood which occupy a place somewhere between paintings and reliefs. At the same time he worked on pictures which integrated text and pictograms, and whose garish colours pointed at least to a passing acquaintance with the stylistic means employed by Pop Art. A year later, LeWitt's work visibly liberated itself from the wall and proceeded towards the third dimension in the form of simply structured objects. In a group exhibition organized by Dan Flavin at the Kaymar Gallery in 1964, LeWitt displayed two works

1966 — Various West German student organizations form the "Extra-Parliamentary Opposition" in response to the Grand Coalition government
1966 — Michelangelo Antonioni makes the film "Blow Up"

17.
Sol LeWitt during the installation of an exhibition,
early 1970s

18.
Retrospective exhibition Sol LeWitt
View of installation, Musée d'Art Contemporain,
Montreal 1978

19. SOL LEWITT
Two cubes vertical, two cubes horizontal
1971, wood painted white

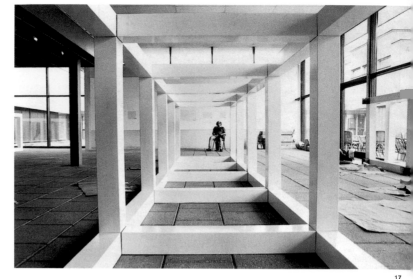

17

"Recently there has been much written about minimal art, but I have not discovered anyone who admits to doing this kind of thing. Therefore I conclude that it is a part of a secret language that art critics use when communicating with each other through the medium of art magazines."

Sol LeWitt

which in spite of their dissimilarity already anticipate important aspects of his more mature oeuvre. *Table with Grid and Cubes* (1963) unites two basic forms, the grid and the cube. On a square table, whose top is divided into 16 squares painted in different colours, three equal-size cubes each with a different number of sides are arranged seemingly haphazardly. All the elements of the work are directly accessible to the eye of the beholder, although the logic of their arrangement is not immediately apparent. On the other hand, *Box with Holes Containing Something* (1963), is, as its name suggests, a cube with a perforated side mounted on a wall; the something it contains is a photograph of a nude woman: this is, by contrast, definitely not accessible to the eye of the beholder.

The work functions in a sense as a hiding place which does not yield up its secret entirely. In his later serial works, LeWitt often played with the idea of elements that remain hidden, although their presence is obvious by dint of the systematics underlying the work. The surface clarity and the actually irrational foundation of his art are already reflected in remarkable fashion in the constellation of the two 1963 objects.

Between 1964 and the middle of 1965, LeWitt worked on numerous wood objects to which he gave a monochrome coat of paint. These were either fastened to the wall or were freestanding in the room. In their sober simplicity, these works could without any doubt be assigned to a reduced "minimalist" formal vocabulary. *Wooden Structure* and *Untitled* (both 1965) mark a noteworthy change in LeWitt's work, to the extent that here for the first time open forms are presented as objects, in that the sides are absent and only the frame is visible. This reduction points to a tendency towards a dematerialization in the work, which was to be gradually consummated in the following years. The same year saw the appearance of his first purely modular work, *Cube-Cube*, a cube composed of 27 smaller cubes whose tautological title reflects its tautological design idea. The white-painted aluminium structure of *Cube-Cube* was no longer made by LeWitt himself, but already factory-produced.

Serial Project No. 1 (ABCD), dating from 1966, ushered in a further lasting shift of emphasis in LeWitt's work. The project consists of a systematic arrangement of numerous closed and open cubic shapes and two-dimensional squares. For better ease of viewing, the formations are arranged in nine separate squares, which in their totality form a grid structure more than four metres square. The scheme underlying the arrangement of the structures on the floor is not immediately apparent to every beholder. What we have is all the "relevant" combinations of closed and open cubes and squares, which in turn

1966 — Minimal Art makes its first museum appearances

1966 — Truman Capote publishes his novel "In Cold Blood"

1966 — Mao Tse-tung unleashes a "Cultural Revolution" in China

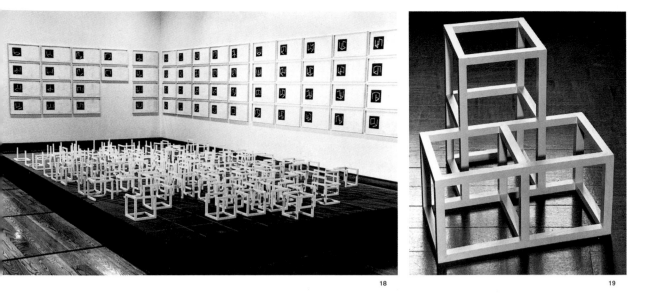

contain closed or open cubes and squares. The ratio of the dimensions of the "enclosing" units to the "enclosed" is laid down at 9 : 1 and s retained in all nine arrangements.

Serial Project No. 1 (ABCD) was the first of many comparable works and marked the start of a serialist, conceptual manner of working on LeWitt's part, concentrating on the shape of the cube as its basic module and combining them by re-ordering the series. The works were now, as a general principle, made in a factory in aluminium or steel according to the instructions of the artist, and without exception painted white in order to minimize the effects of the material. In the serial works, the underlying idea or concept assumes primary importance, whereby LeWitt remains tied to a material realization in order to convey it. The work as executed is to be understood as the information-bearing visualization of the immanent idea.

With his serial projects, in 1966 LeWitt made an imposing exit from Minimal Art, in whose existence he had in any case never believed. While in 1966 he still saw himself as a serial artist, a year later, in his essay "Paragraphs on Conceptual Art", he composed the first important manifesto of Conceptual Art, defining the principles of his own work in this direction. Among other things, in this essay he declared that the conception of a work is superordinated to its execu-

tion, and pointed to a contradiction between a view of art based on visual perception and a conceptual view. He also noted that an idea had to be neither logical nor complex in order to constitute a successful starting point for the work process. Laconically he declared: "What the work of art looks like isn't too important", and asserted the equal status of idea, sketches, models, conversations etc. with the work as finally executed.

Formally, LeWitt's post-1966 modular structures can still be assigned to Minimal Art, to which they are linked by an obvious rejection of all forms of expressivity and self-referential complacency. At the same time, though, to the extent that they take on the status of visualized ideas that are localized within themselves, they leave the field of an art for which the concept of "presence and place" and the concrete experience of the work were paramount.

ROBERT MORRIS

After being trained as an engineer and studying art at the University of Kansas City and the Kansas City Art Institute, Robert Morris moved first to San Francisco in 1950, in order to enrol at the Califor-

> **"You see a shape – these kind of shapes with the kind of symmetry they have – you see it, you believe you know it, but you never see what you know, because you always see the distortion and it seems that you know in the plan view."**
>
> **Robert Morris**

20

nia School of Fine Arts. He lived in San Francisco – apart from a two-year break for military service at Reed College in Oregon – until moving to New York in 1960. In the second half of the 1950s, Morris was active in San Francisco both as a painter and as a member of the avant-garde dance ensemble led by Ann Halprin. Here he got to know Simone Forti and Yvonne Rainer, who moved with him to New York in order to join the Judson Dance Theater. In 1961 he began to study the history of art at Hunter College, graduating in 1966 with a master's thesis on Constantin Brancusi. In New York he soon took up sculpture alongside dance. The first apparently "Minimalist" works, such as *Column*, appeared in 1961, albeit still on the periphery of the Fluxus movement. Originally intended for publication in a Fluxus anthology, and later withdrawn by the author, he composed the statement "Blank Form" at this period:

"Some examples of Blank Form sculpture:

1. A column with perfectly smooth, rectangular surfaces, 2 x 2 x 8 ft (61 x 61 x 244 cm), painted grey.

2. A wall, perfectly smooth and painted grey, measuring 2 x 2 x 8 ft (61 x 61 x 244 cm)."

In contrast to the artists already discussed, it is impossible in the case of Morris between 1961 and 1964 to talk either of an artis-

tic breakthrough or of a logical development in his work. During these years he worked both on austerely geometric sculptures of unparalleled simplicity, and on objects which often either reflected the production process or else used a paradoxical combination of language and object to question traditional ideas of representation. The *I-Box* (1962) for example, when closed, shows the letter (representing the pronoun) "I" inlaid in the wood and provided with hinges. When the box is opened, we see an I-shaped photograph of the naked, grinning artist. Morris here creates a short-circuit which shows up the discrepancy between the abstract linguistic conception of "I" and its concrete visual representation. This not only confuses the beholder, but also awakens him or her to the fact that the idea of the self as something absent is ultimately incapable of appropriate representation. In *Box with the Sound of Its Own Making* (1961) we have a small cube of walnut wood containing a cassette-recorder, which reproduces a three-hour recording of the noise made when the box was being created. In this box, the past (the sound of production) and the present (its condition while being viewed), the production process and the object itself, fuse in a curious way. A greater interest in the process side of art finds expression in virtually all of Morris's works.

1967 — Media theoretician Marshall McLuhan publishes "The Medium is the Message"
1967 — Land Art movement inaugurated in the USA and Europe　　　　**1967 — Arte Povera movement inaugurated in Italy**

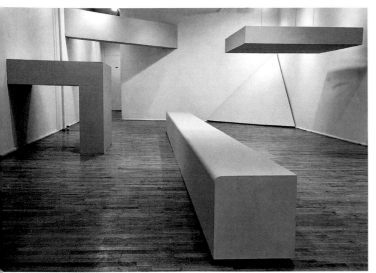

20.
Robert Morris during the installation of his retrospective exhibition at the Whitney Museum of American Art, New York 1970

21.
"Plywood Show" by Robert Morris
View of installation, Green Gallery, New York 1964

21

After still displaying geometric-abstract works along with mysterious objects at his first solo exhibition at the Green Gallery in 1963, he staged his much-vaunted "Plywood Show" at the same venue in December of the following year, exhibiting nothing but simple geometric structures. A total of seven sculptures – until 1968 Morris himself referred to his works as sculpture – were distributed around the rooms of the gallery, and in some cases made explicit reference to the architecture of the exhibition space. The works were without exception made of plywood, and painted light grey. *Untitled (Cloud)* was a large square suspended about two metres above the floor by wires from the ceiling, *Untitled (Corner Piece)* was a triangular item, taking up one corner of the room, while a further work in the form of a beam occupied the space above head-height between two walls in the entrance hall. In the approximate centre of the gallery, a rectangular shape of considerable length was laid on the floor parallel to the wall. All of the objects were placed in such a way that the beholder could comfortably walk around them. The simple forms and the uniform grey in which they were painted gave the works, if anything, a visually uninteresting appearance. Their placement, and the absence of internal relationships, seemed conversely to emphasize their relationship to the beholder and to the room. Morris, and this was new in the context

of Minimal Art at this time, was evidently equally interested in the visual appearance of his works, their relationship to their surroundings, and their effect on the beholder. His starting point was "body perspective", in other words, for Morris, perception was in principle bound up with the body and not limited to the sense of sight, which explains the relatively large dimensions of his works.

The period between 1965 and 1967 saw the appearance of different versions of L-beams, *Untitled*: at least two, mostly three identical L-shaped objects, which were installed each in a different position – standing upright on the narrow side, lying on the long side, and standing on one edge. They can be seen as demonstration objects, which arouse the beholder's awareness of his dependence on his perception of the associations between things and situations. In spite of knowing that the objects are identical, he does not succeed in perceiving them as such. Depending on their distance from the wall, the position in which they are presented, and the position of the beholder, the objects appear to be of different size and shape. Based at first on the Gestalt theory and later influenced by the phenomenology of Maurice Merleau-Ponty, Morris's Minimalist sculptures also evince references to his experience as a dancer and performance artist.

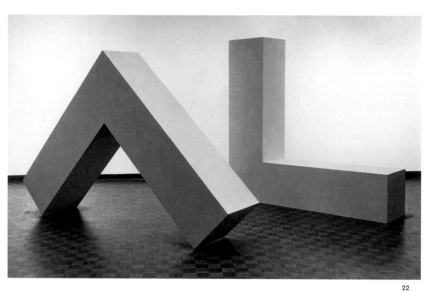

22. ROBERT MORRIS
Untitled (L-Beams)
View of installation at the Green Gallery,
New York 1965

23.
"Primary Structures"
Exhibition catalogue, The Jewish Museum,
New York 1966

22

In 1966 Morris translated the idea of constantly changing situation-dependent perception into the conception of a series of works whose appearance itself now constantly changed. These differed from the objects whose shape and size are clearly defined to the extent that they were composed of elements some of which were identical and some not. During the exhibition at the Leo Castelli Gallery in March 1967, Morris changed the spatial arrangement of the individual components every day. In the process his concern was to ensure that the respective arrangements could always be perceived as a totality in the sense of a Gestalt to which the individual elements were subordinated. In works such as *Untitled (Stadium)* the process of perception corresponds to the process of design with respect to the respective unfinished nature and variability of the piece. In a certain sense, Morris's "variable" works already herald the exit from "Minimalist" object art which manifested itself in 1968 in the form of his felt pieces and his article titled "Antiform". While in his 1966 "Notes on Sculpture" Morris had still described form as the most essential characteristic of sculpture, he now wrote: "Disengagement with preconceived enduring forms and orders for things is a positive assertion. It is part of the work's refusal to continue estheticizing form by dealing with it as a prescribed end." The way was free for a new aesthetic in which the work was not regarded as the end product, but as the starting point of an art seen as an open process.

Pop Art versus Minimal Art

The New York art scene in the 1960s was a village where everyone knew everyone else. There were a total of about a hundred galleries at the start of the decade, some twenty of which included young contemporary artists in their exhibition program. The art market was not over-active, prices for works even of well-known artists were moderate, and sales were in any case few.

The work of the Abstract Expressionists (Jackson Pollock, Willem De Kooning, Mark Rothko and a few others) had taken time to establish itself on the market; this only happened in the late 1950s, after it had achieved international recognition. For younger artists, by contrast, it was well nigh impossible to live by their art alone.

In 1962 Pop Art became the first movement of a younger generation to enjoy substantial success with the New York public. Progressive galleries displayed the new, colourful works at solo or group exhibitions, which received an amazingly good press in the magazines

1968 — Assassination of black civil-rights leader Martin Luther King in Memphis, Tennessee
1968 — Suppression of the "Prague Spring" by the Soviet military **1968 — US soldiers massacre Vietnamese villagers in My Lai**

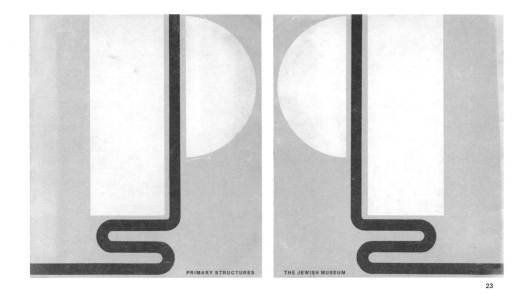

PRIMARY STRUCTURES THE JEWISH MUSEUM

and daily newspapers. By 1963 and 1964, the trend was soon being promoted and acknowledged through numerous museum exhibitions. Although the first Minimalist works had appeared at more or less the same time as those of the Pop artists in the early 1960s, and made their gallery debut only one year later in 1963 (Richard Bellamy exhibited Pop Art, Neo-Dada, and Minimalist objects together at several exhibitions at his Green Gallery in 1963), it took a relatively long time for them to achieve recognition at the institutional level. After a few presentations in smaller museums outside New York, Minimal Art's definitive breakthrough only came in 1966 with the "Primary Structures" exhibition in New York's Jewish Museum.

The early success of Pop Art had had a lasting effect on the climate within the New York art business. New trends in American art now began to enjoy a hitherto unheard-of degree of publicity. Suddenly it came to be of enormous importance who was exhibiting what where, and who was writing what and where about these exhibitions. Alongside the arts pages of the daily newspapers, the three arts magazines "Arts", "Art International", and "Artforum" kept their clientele up to date on the new trends. Even fashion magazines such as "Harper's Bazaar" devoted multipage articles to the new style of New York's creative talents. Within a short time, this change of public mood resulted in a considerable growth in visitor-numbers for the few galleries which had always taken an interest in young art, but also led to young artists seeing themselves under greater pressure than before to regard their fellow artists as competitors and in some cases even as rivals, and to behave accordingly.

The canonization of Minimal Art by conservative critics

In spite of not having a clear theme – altogether more than forty artists took part – the "Primary Structures" exhibition, with its extremely effective staging, had made a major contribution to the fact that the works of the "Minimalists" were now more widely discussed in the illustrated magazines and arts pages. In addition, the essays "Specific Objects" by Donald Judd and "Notes on Sculpture I & II" by Robert Morris made it clear to everyone by the end of 1966 that there were two largely incompatible interpretations of three-dimensional work, revealing Judd and Morris as opposing theoreticians of the new movement. In this situation, conservative critics reacted with vehement polemics.

1968 — Major student unrest in Germany, France, Belgium, Japan, Mexico, Yugoslavia and Poland; attempt on life of student leader Rudi Dutschke in Berlin 1968 — Stanley Kubrick makes the film "2001 – a Space Odyssey"

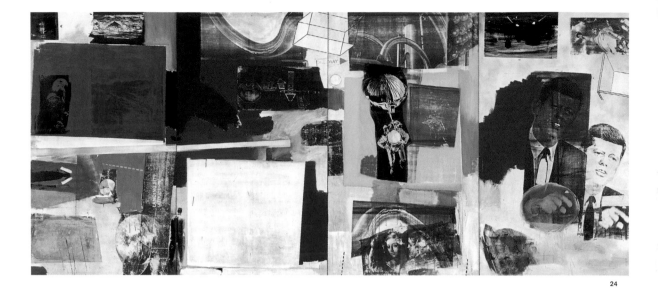

First of all, Clement Greenberg attacked Minimal Art in "Recentness of Sculpture", by comparing it to good design and accusing the artists of, among other things, confusing innovation with novelty. But all this, he said, had nothing much to do with art, and as "Novelty Art" was to be written off as just as insignificant as, for example, Pop Art or Op Art.

The critic Michael Fried, by contrast, took Minimal Art far more seriously, calling it "Literalist Art" and seeing it paradigmatically as a threat to formalistic Modernism. In his 1967 essay "Art and Objecthood" he took it upon himself to defend modernism against this attack. Fried thought that Minimal Art was abandoning the two basic principles of modernism: a clear demarcation between art and non-art, and an unambiguous division of genres. He thought the challenge of ready-mades had returned, albeit under different colours.

Minimal Art in and beyond its Time

Art rarely arises in the rarefied atmosphere of theory. Like any authentic art, Minimal Art too was a child of its age, and, like Pop Art, reflected consciously or unconsciously the reality of society in 1960s America, a society that was undergoing a radical upheaval.

Following the 1950s, a decade marked by the Cold War, the anti-communist witch-hunts, and prudish bigotry, the time was ripe for far-reaching changes in politics and society. The election in 1960 of John F. Kennedy as president gave the movement for renewal a symbolic figure of the highest rank. For the first time, broad sections of the public became aware of racial discrimination, social and economic injustice, as well as such issues as homosexuality and equal opportunities for women. For the first time, these questions were debated in public. Various "liberation" movements increasingly threw off the shackles of state supervision, holding their own demonstrations to make their voices heard, and – at least on paper – quickly saw their aims realized. All this happened against the background of a prospering economy, because from the economic point of view, the USA in the early 1960s experienced the inauguration of the late-capitalist age of mass-production and mass-consumption, and in the form of television, there was a mass medium available which could effectively and literally bring home the alleged advantages of increasing numbers of new products.

Artists reacted to these developments in different ways, but few were left totally unmoved. While Pop Art integrated the banal iconography of the consumer society into high art, Minimal Art used prefab-

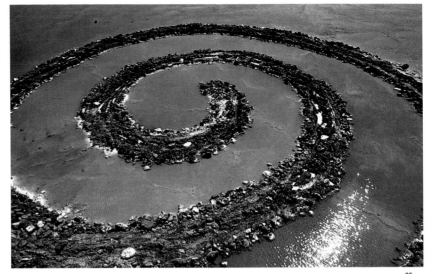

24. ROBERT RAUSCHENBERG
Axle
1964, oil and silkscreen print on canvas, 4 parts,
274 x 610 cm
Cologne, Museum Ludwig

25. ROBERT SMITHSON
Spiral Jetty
1970, Rozel Point, Great Salt Lake, Utah

icated materials and transferred the principle of the division of labour into abstract art. Andy Warhol called his studio a "factory" and produced his pictures using the silk-screen technique, while Donald Judd spoke of art in the sense of "one thing after the other".

By incorporating the logic of serial production into art, Pop Art and Minimal Art were taking account of the changed conditions of late-capitalist consumer society, and narrowing the gap between high culture as practised in the institutions devoted to it on the one hand, and mass-culture, much derided or written off as kitsch on the other. The intention was clearly not always critical, but for art it still meant a paradigm shift, and the genie could not be put back in the bottle. The idea of the artist as a lone creative genius had definitively had its day, as had the idea of a work of art as a unique original. Remarkably, it soon became clear that the value and aura of a work of art were in no way dependent on its unique status, but rather that they could be ensured on the basis of other criteria in an institutionalized art world.

It was partly the relatively problem-free integration of the avant-garde into the mechanisms of the art market, and its rapid acceptance in the institutions of established visual art, which caused such artists as Daniel Buren, Hans Haacke and Michael Asher to turn their atten-tion to a critique of the institutional context of art. At the same time, a series of other artists applied themselves to a comprehensive conceptualization of their work. The result of their endeavours was an art that often dispensed with a saleable object and was presented, totally dematerialized, as a thought-work. By the later 1960s, the Minimalist discourse concerning the object had already lost much of its critical potential, and appeared to many young artists as simply another part of the establishment. With Process Art, Land Art, Body Art, Performance Art and Conceptual Art, a younger generation of artists went beyond Minimal Art and turned to problems which Minimalist practices had left untouched. This pluralistic extension of art was however only possible under the conditions which Minimal Art had made possible in the first place. It was only the rupture with formalistic modernism as ushered in by Minimal Art that had led to a recognition of the conventional nature of art. Thus it was no longer possible to lay down the law concerning what was art and what was not: the field could be continuously extended in artistic practice. This open situation, which we take for granted today, needed to be battled out in the 1960s. For this reason if for no other we should see Minimal Art as an important milestone on the road to liberation, from whose effects we are still benefiting today.

1969 — First test flights of the Franco-British supersonic airliner Concorde
1969 — On 21 July American astronaut Neil Armstrong becomes first man to step on the moon

steel-magnesium plain

Steel and magnesium, 36 parts, each 9.53 x 30.5 x 30.5 cm, overall 9.53 x 182.88 x 182.88 cm
Private collection

"what my sculpture has in common with science and technology is an enormous interest in the features of materials."

Carl Andre

b. 1935 in Quincy (MA)

Like almost no other artist of his generation, Carl Andre developed and built on his work with great consistency. Within just a few years, from 1958 to 1966, he prepared the basis of his artistic approach, starting with hand-worked wooden sculptures and going on to floor-related works that completely involve their surroundings. In early interviews and statements Andre declared that he was interested in "sculpture as place", and having achieved this he developed his oeuvre within parameters he defined himself. Andre's concept of "sculpture as place" can be regarded as extremely modern, although it also has archaic features. Andre grew up in Quincy, a small town on the Massachusetts coast that has many abandoned quarries around it. In 1954 he travelled throughout England visiting several historical sites, including Stonehenge. Many of Andre's outdoor sculptures exhibit references to the elementary simplicity of such stone-age monuments, for example, his *Stone Field Sculpture* (Hartford, Connecticut, 1977): here 36 heavy, up to eleven-tonne ice-age erratic blocks cover a large lawn area.

Steel-Magnesium Plain consists of 36 square steel and magnesium tiles laid in a square. The plain starts at one corner with a steel tile beside which the other tiles are placed alternately, resulting in a chessboard pattern. This sculpture is one of Andre's *Plains*; 36 elements in two different metals, 18 of each, which the artist arranges in a square. Due to the different materials, each work makes a different impression despite the same configuration of 36 tiles.

Because of the surface structure of the two materials, the overall combination of steel and magnesium seems dull; unlike, for example, aluminium or copper, they do not brightly reflect the light. Homogenous in appearance, the elements in Steel-magnesium Plain seem to move closer together; the plain laid out on the ground draws the room to it, while at the same time seeming to repel it due to its opaque, cohesive character.

The work appears to have clicked in with the molecular structure of the surrounding room so that none of its elements can evade being revaluated. As a result, it is difficult for the beholder to make out figurative references In these ground sculptures – the city squares and the plinth by Alberto Giacometti (1901–1966) reappear here depopulated, or else seem to have disintegrated. The eye is compensated for this strict reductionism by the grey and brown shades of the steel and magnesium tiles: white walls, light brown flooring and greyish-brown metal are the new elements in this sculpture. *Steel Magnesium Plain* inevitably integrates its surroundings as an integral component of the work. The beholder too is forced to collaborate more actively than usual in experiencing the work by being challenged not just to enter the exhibition room but also to walk on the exhibited works.

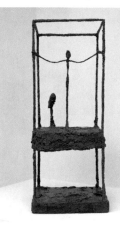

Alberto Giacometti, The Cage
(Woman and Head), 1950

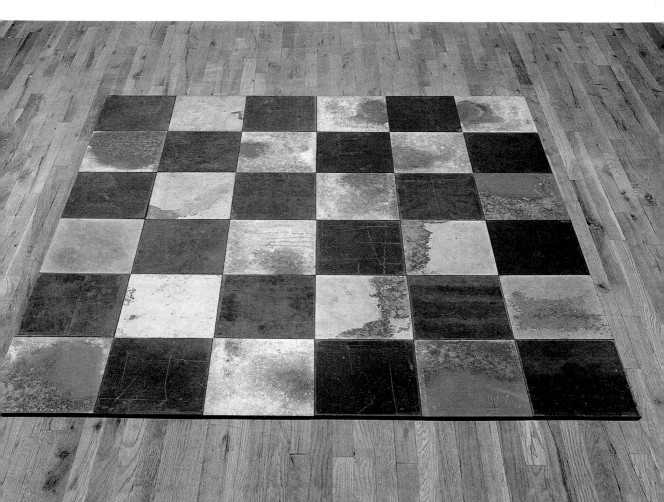

тenth copper cardinal

Copper, 10 parts, each 50 x 50 x 0.5 cm, overall 250 x 100 cm
Berlin, Staatliche Museen zu Berlin – Preußischer Kulturbesitz, Nationalgalerie, Collection Marzona

Carl Andre's radical approach to sculpture was not easily understood when he began to exhibit in the mid-sixties. According to John Weber, the former director of the Dwan Gallery, most visitors to Andre's first one-man exhibition "Eight Cuts" in Los Angeles (1967) did not dare to enter the gallery and left after a short glance at the installation. The entire floor of the gallery was covered with concrete capstones with eight open areas revealing the wood floor beneath. The viewer had no choice but to walk on the stones in order to enter the gallery. In 1967 this was too much to ask for most of the audience.

For the sculpture *Tenth Copper Cardinal* Andre placed ten square copper plates in two rows of five forming a rectangle with one shorter side touching the wall. The plates are machine made and betray no touch of the artist's hand. Installation involves no welding, bolting, carving or drilling, the usual hallmarks of traditional outdoor sculpture. The placement of the plates is the extent of the installation. Andre breaks not only with the handcrafted ethos of traditional American steel sculpture, which is exemplified most prominently in the work of David Smith, but also with the idea that sculpture must transcend its materials and be read by the viewer in purely pictorial and figurative terms.

There is no beginning or end, no preferred direction to the piece, nor is there a pedestal or depth beyond the thickness of the plates themselves. Each plate is of equal importance and as a whole they exist on the floor as a tangible fact like the floor itself, and like a floor can be walked on at any point. The weathering of the copper provides its own natural patina. The artist, by positioning the plates, defines the field of vision. But the viewer brings his own sense of sight, touch and direction.

As his friend and colleague Frank Stella would say, "What you see is what you see." In this case, ten copper plates on the floor or ground. This attitude the two artists share. The specific choice of metal assumes greater importance when other sculptural options and conventions are removed. The viewer has arrived at a place. *Tent Copper Cardinal* strives for and achieves a primary viewing experence – an aesthetic whiskey, taken neat.

> **"мy work is atheistic, materialistic and communistic. ıt is atheistic because it is without transcendent form, without spiritual or intellectual quality. мaterialistic because it is made out of its own materials without pretension to other materials ᴀnd communistic because the form is equally accessible to all men."**
>
> **Carl Andre**

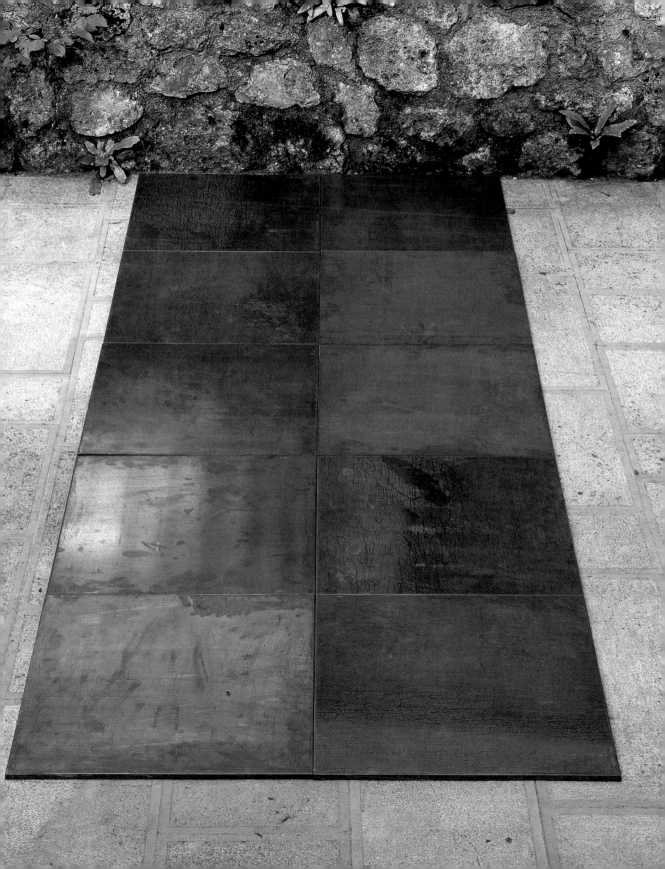

aluminum-zinc Dipole E/W

Aluminium, zinc, 100 x 100 x 0.5 cm
Berlin, Staatliche Museen zu Berlin – Preußischer Kulturbesitz, Nationalgalerie, Collection Marzona

Although Minimal art had been fully integrated into high culture by the end of the sixties, the public reception of Minimalist works remained very complex during the seventies. One of the most outstanding examples of how Minimal art encountered public resistance occurred in 1976 when the Tate Gallery in London announced the purchase of Carl Andre's *Equivalent VIII* (1966). British newspapers picked the story up and transformed it into a real scandal. For several days all kinds of people were given the opportunity to publicly comment on the "unbelievable" fact that the Tate Gallery was willing to spend a huge amount of taxpayers' money to purchase 120 ordinary fire bricks. Most comments revealed a complete lack of understanding; Keith Waterhouse, for example, stated in the "Daily Mirror": "Bricks are not works of art. Bricks are bricks. You can build walls with them or chuck them through jewellers' windows, but you cannot stack them two deep and call it sculpture." In fact Andre could do exactly that and the challenge of Minimal art to the public expectation of what art might be remains alive even in our postmodern pluralistic age.

In *Aluminum-Zinc Dipole E/W* two rectangular plates are placed next to each other to form a square. The seam that joins them runs either longitudinally or laterally depending on the viewer's orientation. The differing weights of the zinc and aluminium plates and the different resistance of their surfaces to scratching or oxidizing create tension between the two parts and inevitably add an element of painterly composition to the silvery blue surface. The two plates can be placed either in isolation on the ground as a single work, or put together with other *Dipoles* to define an entire space. Since the sculpture can be walked around and peered over by the viewer, there are varying degrees of reflection to be seen in the dual surface. The longitudinal or lateral seam running down the middle also plays a role here. Andre alludes, perhaps unconsciously, to his contemporary, the painter Brice Marden (b. 1938) and his *Grove Group* paintings (begun in 1973) for example. Earlier in 1966 at the Bykert Gallery Marden had named one of his paintings in the exhibition *For Carl Andre*.

The literal flatness of *Aluminum-Zinc Dipole* ridicules Clement Greenberg's commandments on abstract painting's adherence to flatness. Now the sculpture is flat. Volume, one of the primary aspects of traditional sculpture, has been abolished, and the work appears as pure material and mass. The simplicity of its form literally defines place from the ground up.

Brice Marden, Grove Group III, 1972–73/1980

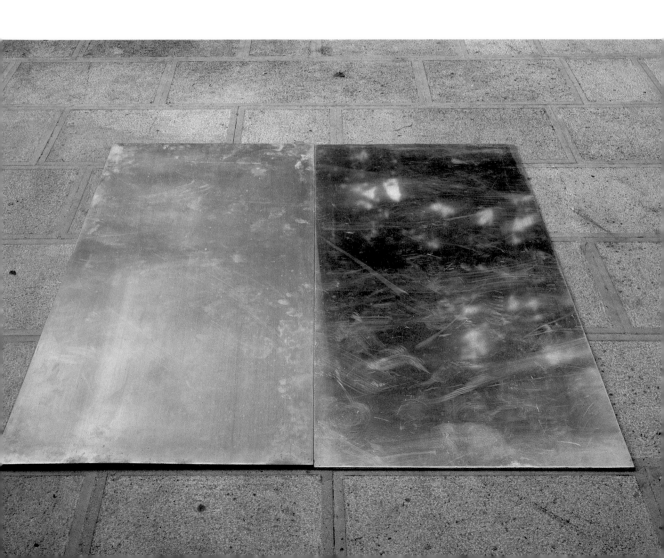

Blue Box

Fluorescent light, metal, 170 x 60 x 60 cm
Berlin, Staatliche Museen zu Berlin – Preußischer Kulturbesitz, Nationalgalerie, Collection Marzona

b. 1926 in Agios Nikolaos (Greece)

Stephen Antonakos started his artistic career in the late forties as an autodidact while he was working as an illustrator to support himself. In the mid-fifties he began to employ found materials which he combined in three-dimensional assemblages. During this period his work reveals influences of Lucio Fontana (1899–1901), Alberto Burri (1915–1995) and Robert Rauschenberg (b. 1925). At the beginning of the sixties Antonakos discovered fluorescent light, which soon became his primary medium. During the sixties Antonakos' ground-breaking fluorescent-light sculptures were included in many important group exhibitions, and in 1966 he began to exhibit at the Fischbach Gallery, New York.

Many works by Antonakos concern themselves with the special relationship of sculpture to architecture within public spaces. Since the mid-sixties, Antonakos has created sculptural environments using industrial lighting systems, particularly bright monochrome fluorescent tubes. He combines them in numerous glass and metal assemblages, weaving the thin glass fluorescent tubes through old or modern buildings, such as underground train stations, power plants and religious sites.

Blue Box is an early work formed by two diverse parts, a smooth-finish steel base roughly two-thirds the height of the piece, and a cubic frame of blue neon tubes placed on top of it. Approaching the piece the observer confronts a simple structure that combines an archaic presence with the technology of modern times. The colour of the light is a powder blue and decisively modifies the ambiance of the

space. The recognition by Antonakos of the power of coloured light i a controlled environment led to the creation of more complex publi sculptures using the industrial language of neon to compete with th outside world and all its various distractions. Antonakos' large an elaborate fluorescent installations in both public buildings and ou door spaces are not simply decoration, but become new element which re-structure their environments. In an outdoor installation a P.S. 1 in New York in 1999, the light sculptures neither rejected no demanded the viewer's attention, but maintained an impassive rela tionship to the sky. As the sun began to set, the *Chapel for P.S.* grew in intensity and colour and began to engage the night sky, crea ing a horizon with stars which appear to have just been switched o As with many of Antonakos' works, the *Chapel for P.S. 1* allowed th viewer a calm and meditative experience, providing a defined space c silence and beauty. Clearly intended to evoke an atmosphere of poe ic spirituality, Antonakos' work has distanced itself from the objectiv attitude of most Minimal art. As the artist has stated in interviews, his work is meant to create "the possibility for a kind of higher consciousness".

Chapel for P.S. 1 (detail), 1999

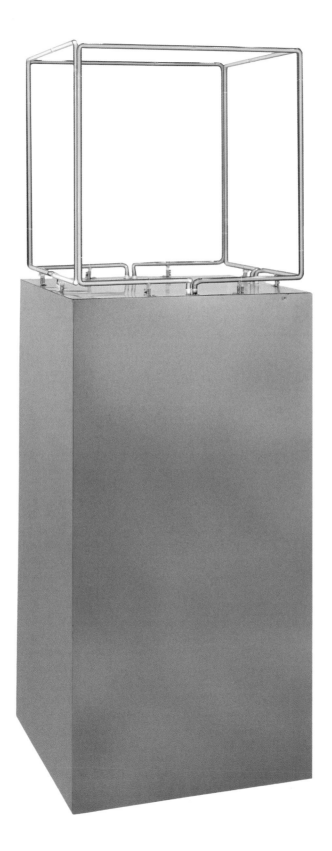

Primary Light Group: Red, Green, Blue

Oil, synthetic polymer on canvas, 3 panels, each 153 x 153 cm, overall dimensions variable
New York, The Museum of Modern Art, Philip Johnson Fund, 1969

b. 1929 in Seattle (WA)

Like most artists of her generation, Jo Baer had a solid academic background, but unlike most of her fellow-artists she actually worked as a scientist for a considerable period of time. Baer majored in biology in 1949 and then moved to New York where she undertook graduate work in physiological psychology at the New School for Social Research.

Baer's Minimal paintings reveal her substantial knowledge of physiological perception as well as her fascination with the mechanics of optical phenomena. Most of Baer's paintings in the sixties share a recurring theme: a black band delineating the physical perimeter of the canvas along with a thinner interior border of a generally lighter colour, which separates the dark outer frame from the white central core. Different size canvases demand different colours and thickness of Mach bands, the name she gives to the borders. Her works can be considered as retinal abstractions activated by the delicate red, green or blue borders, which act as shutters or apertures. The paintings use light in a non-illusionist manner and retain a Spartan rigour. Baer investigates the physical matter of paint on canvas without emphasis on any one component of the process over the others. This is to avoid a pictorial hierarchy and maintain visual flatness. Surface, line, colour, paint have no special preeminence, but share an objective visibility to all.

Primary Light Group: Red, Green, Blue is part of a series of a dozen paintings each composed of primary-coloured canvases of different sizes that are bound together by the systematic use of one saturated colour. Each thin border line gives a special hue to the all-white surface; the colour insert influences the visual field and like a subliminal wave differentiates the luminance of each canvas. The triptych also reflects Baer's interest in serial works or progressions that provide a non-illusionist sense of movement or composition. The works of the series could be combined in more than 8 000 000 possible ways, none of which could be considered superior to any other.

Baer's painting in general at this time and her reductivist abstract painting in particular were involved in various skirmishes over the supremacy of one form of art over the others. Minimalist fundamentalists like Donald Judd questioned the relevance of painting when set against the new rules of art imposed by him and other Minimalist sculptors. Baer responded to this discourse with paintings that are to be understood as retinal facts presented to the viewer for visual completion. From her perspective, whatever was "old-fashioned" was in the mind, not the eye of her viewer.

> **"some recent wall boxes look hollow ... some recent paintings redefine colour as luminance (reflected light), and use this new colour spectrum so that no illusion of depth is possible at all."**
>
> **Jo Baer**

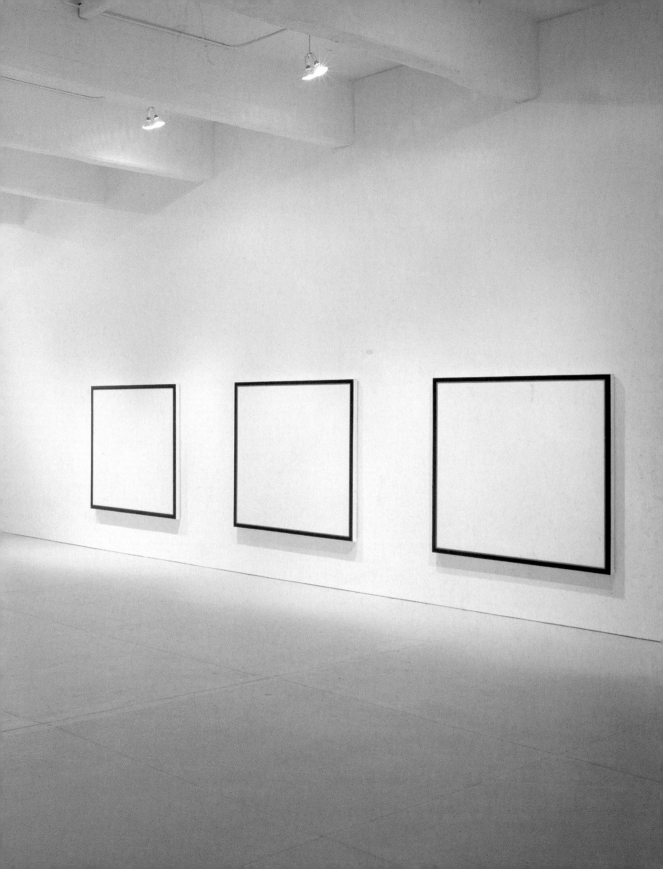

cube NO. 2

Glass, chrome metal, 31 x 31 x 31 cm
Berlin, Staatliche Museen zu Berlin – Preußischer Kulturbesitz, Nationalgalerie, Collection Marzona

b. 1939 in Chicago (IL)

Larry Bell was a leading figure of the Los Angeles Finish Fetish movement (a school of thought that developed in nineteen-sixties' Los Angeles, based on the subculture of cars and surfboards). In 1962 Bell had developed a unique method for vacuum-coating glass which allowed the production of coloured, transparent and highly reflective glass surfaces. Employing the cube format, Bell's work of the sixties combined the visual complexity of Op Art with the formal rigidity of Minimalist sculpture. He first showed his cubes at the Pace Gallery, New York, in 1965.

Cube No. 2 consists of an immaculate vacuum-coated glass cube standing on a transparent pedestal. The cube is transparent, but tinted with a burnt ochre hue, which filters the light to create a dim inner core. The surface of the cube is dark but reflective, and as such resembles a mirror, but one that can be peered into. Seen from far away, the brilliance of the cube defines a visible volume above an invisible pedestal, but approaching the work one grasps its two-fold quality: the six faces of the cube no longer appear as a solid volume, rather they become transparent and gravitate towards the inner core. The edges are made of chrome-plated metal and the thin blades visually separate the six faces of the cube, so that they appear to float independently of one another. The depth created by the darker interior counterbalances the mirroring effect of the glass surface. This effect has been achieved by a process of vacuum-coating that uses metal vapours to apply the colour to the glass. The interior space in dim amber light is a resting place for the eyes and mind of the obser-ver, where he can study the reflected and displaced image of his body-double, while everything else surrounding the physical body fades away. Body and shadow are both reflected by the glass and at the same time enter the glazed surface to re-emerge on another face.

All this contradicts the East-coast approach to the new work being produced in three dimensions. The shiny and superfinished surfaces of Bell's cubes create visual ambiguity and illusion. Instead of Judd's credo "one thing after the other" they collapse many impressions into one object and demonstrate a more playful notion of the minimal object, a typical Californian attitude shared by artists like Craig Kauffman (b. 1932), John McCracken and others.

Bell's works of the mid-sixties address the space they are installed in or designed for while defining their own physicality in relation to it. They interact with the surroundings and the observer, sometimes multiplying both of them, at others collapsing one into the other, an effect Bell learned early on in his first paint, glass and mirror pieces. The sculptures are constantly changed by elements outside of themselves such as architecture or nature, which results in the same piece appearing different in size and colour when placed in different locations.

> **"my works are about 'nothing' and illustrate in the most literal sense 'emptiness and lack of content'."**
>
> **Larry Bell**

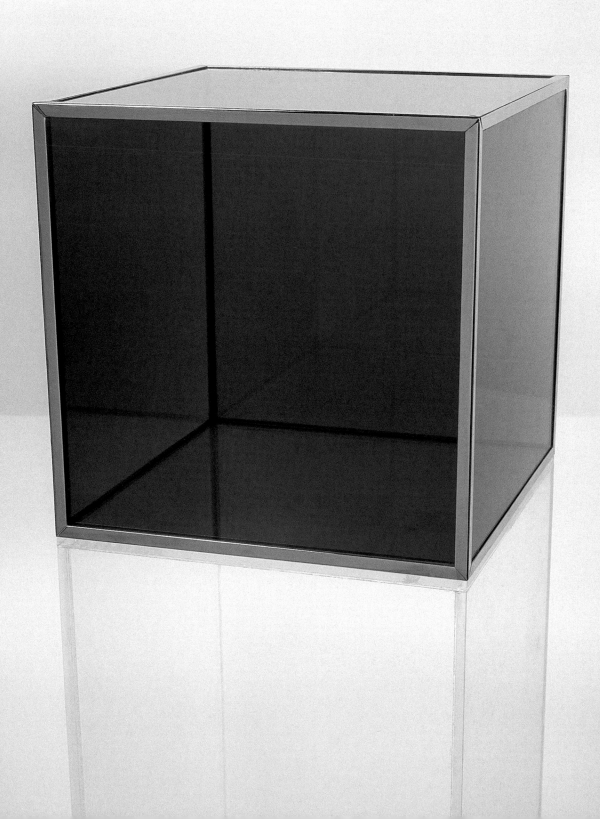

Three elements

Painted plywood, aluminium, 3 parts, each 284 x 122 x 53 cm
Berlin, Staatliche Museen zu Berlin – Preußischer Kulturbesitz, Nationalgalerie, Collection Marzona

> ## "My pieces are not at all that large … I am much more involved in presence than I am in scale."
>
> **Ronald Bladen**

**b. 1939 in Vancouver (BC),
d. 1988 in New York (NY)**

Three Elements is a pivotal work of art both for Robert Bladen's oeuvre as well as for the creative development of a wider group of artists who were his contemporaries; three free-standing trapezoids approximately three metres apart from each other are aligned in a row.

The three trapezoids are slanted to 65 degrees, and their centre of gravity is so far offset that they appear barely stable. It was this aspect of the sculpture that made it so dramatic when shown in "Primary Structures" at the Jewish Museum in New York in 1966.

The elements are nearly three metres high, built in plywood and painted with black enamel. One of the oblique wider faces is clad with a smooth aluminium surface that absorbs and softly reflects light. The contrast between the darkness of the black box, its tar-like appearance, and the silky film of aluminium establishes an intriguing relationship between the elements and the space where they are situated. This contrast has a similarity to another of Bladen's sculptures, *Untitled (Curve),* 1969, where the definition of the inner and the outer part of a curving semi-circular wall in relation to the surrounding space is emphasized by the opposition of the exterior black and the interior white colour. *Three Elements* stand still in sequence, thus creating an activated interior space, a series of angular pockets that lie in the shadows cast by the towering black trapezoids. This aspect relates to Bladen's life-long interest in natural phenomena and the shadows cast by natural forms (he once spoke of the shadow formed upon the water by a wave about to crest).

Bladen, whose parents had immigrated to Vancouver, British Columbia from Britain, had visited Stonehenge in England and spoke of his disappointment after finally seeing the megalithic ruin. His disappointment lay in what he felt was a lack of tension between the standing architectural forms. Thus in *Three Elements* the spaces established between the trapezoids are part of the whole; they participate in it while being discreetly removed and detached from it. Walking along the main axis towards one element the viewer approaches the oblique plane of the aluminium surface with no anticipation of any volume behind it; the observer's own shadow appears on the silver plane, lingering on it to give the impression of a faded mirror or rather a colourless metal surface.

The complexity of Bladen's sculpture is evident when one deviates from the central axis. At that moment the three volumes re-acquire physical mass and begin to engage with space in all directions, thus linking the viewer and the sculpture into the same spatial context. Circling the forms, the viewer begins to understand Bladen's expressive work and can ponder the space, balance, verticality and sense of dynamism created by it. The piece is designed and constructed to withstand a wide expanse of space around it, and one steel version of *Three Elements* in North Carolina is located in a landscape setting where the trapezoids become territorial markers; people see the monoliths from a distance from whichever direction they approach. Once near the sculpture they understand that the forms have a special character and proportion which are monumental as well as human in scale.

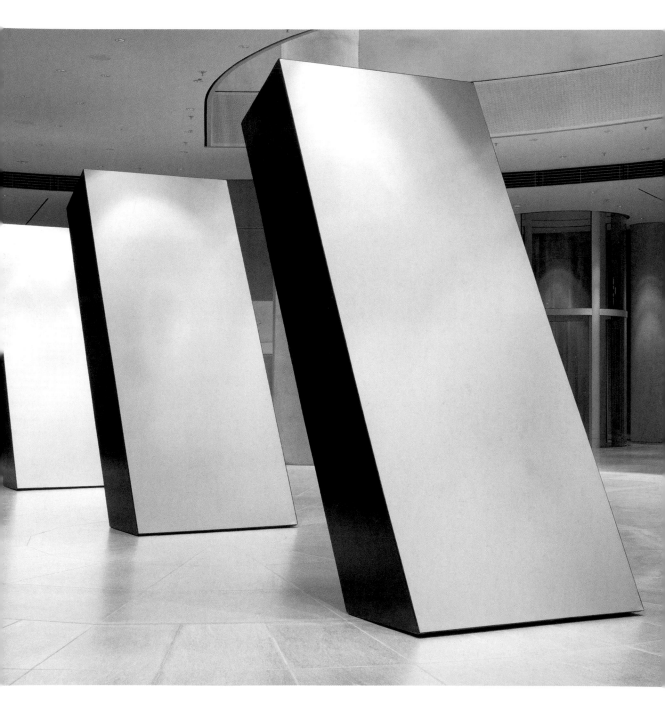

untitled (curve)

Painted plywood, 284 x 671 x 457 cm
Berlin, Staatliche Museen zu Berlin – Preußischer Kulturbesitz, Nationalgalerie, Collection Marzona

This sculpture is a good example of Ronald Bladen's interest in defining an extended artificial space where the three-dimensional form of the piece and the observer interact alone between themselves, and between themselves and the environment. *Untitled (Curve)* is a curvilinear structure forming almost half of a circle. The interior side of the curve is a backward-leaning wood surface painted bright white, which causes its materiality to dissolve in an enigmatic floodlit space. This white immaterial zone, partly embracing an observer who is walking close to the slanting surface and partly pulling away from him, prevents any possible peripheral vision and flows in circular motion around the observer, who consequently loses balance and begins to lean towards the wall.

There is a similarity in this eccentric movement with Richard Serra's later sculptures, like *Tilted Arc* (1981), which swirl around the viewer in a rhythmic enclosure. When Bladen was building his monumental wood sculptures in the late sixties and early seventies, Serra would visit him while he was hard at work. Peering into the intricate structure of his complex pieces before they were covered in plywood and painted black, Serra would comment on them by asking Bladen why he was covering up all the goodies inside. This exchange illustrates the difference between Bladen and his younger Minimal contemporaries. Bladen's romantic pride in his work is personal and directly opposed to the Minimalist credo of non-aesthetic aesthetics and its total rejection of pictorial narrative.

Untitled (Curve) is a measured but dynamic volume built, as are most of Bladen's works, with an intricately designed interior and heavily bolted wooden structural frame. Sheathed in thin plywood and then spackled and painted with a coat of enamel similar to the coating applied to industrial steel structures, it is finished to a smooth surface. *Untitled (Curve)* is composed with a series of trapezoidal curved shapes whose serial juxtaposition creates the slanting walls of the inner circle. The work has a dualistic nature: a front and a reverse side that becomes evident only when one reaches the end of the curve and turns round to the other side. Here, the wall is solid and perfectly vertical. Unlike the inner surface, which is glowing white, the outer surface is painted black, thus absorbing most of the ambient light. The two sides also absorb sound differently: while on the white side sound bounces around the curve, on the black side it slips away. A kind of meditative aura surrounds many of Bladen's artworks and in the case of *Untitled (Curve)* this is generated by the repetitive movement of the viewer walking along the wall in a rhythmic motion, with no precise beginning or end.

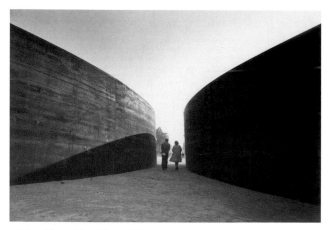

Richard Serra, Clara-Clara, 1983

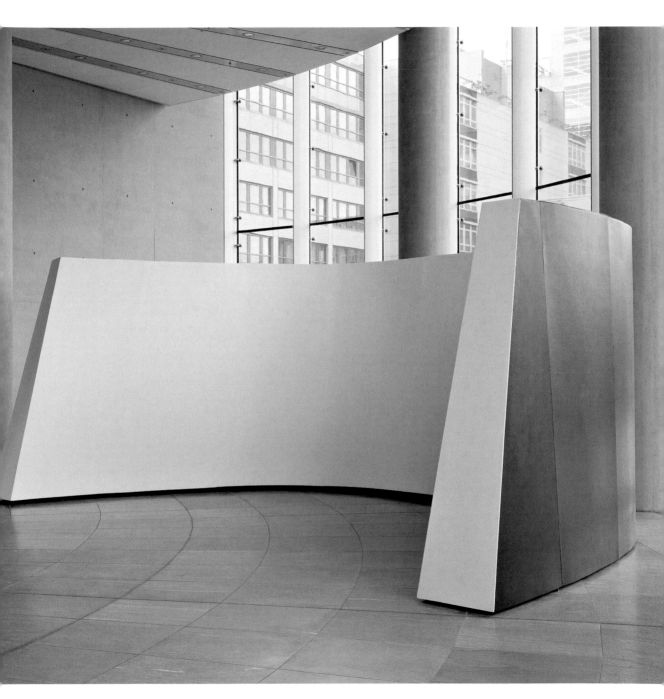

The cathedral Evening

Painted plywood, 900 x 720 x 300 cm
Berlin, Staatliche Museen zu Berlin – Preußischer Kulturbesitz, Nationalgalerie, Collection Marzona

Because Ronald Bladen was older than most of the sculptors associated with Minimalism and came from a highly educated, cultured background, he became an authority figure to many of them, as well as to the many artists he taught at the Parsons School of Design (where he was a member of the faculty from the mid-seventies until his death in 1988). He gravitated from Vancouver, BC to San Francisco in the fourties and became involved in various anarchistic political and literary movements culminating in the Beat Generation. Bladen could count Henry Miller, Jack Kerouac and Allen Ginsberg among his friends. Bladen's rapport with artists was legendary; after his first summer at the Skowhegan School of Painting and Sculpture in 1981, he was asked to return the very next year because of the effect he had on the students. Since Bladen had spent just over half of his life as an accomplished and exhibited painter, his criticisms of painting were just as valued and respected as his judgements on sculpture. He knew what he was talking about. Bladen's presence as a person was ultimately reflected in his sculptures. They were authoritative in form, dramatic in intent, and conveyed his convictions to the fullest.

The Cathedral Evening is a complex and dramatic structure that Bladen developed with his distinctively unique approach to creation. First he created in his mind a three-dimensional, dynamic visual form (reminding one of the Cubist or Constructivist experiments with space and dynamism) that he then committed to paper. He then challenged the force of gravity and experimented with the many ways each part of the sculpture could influence the others, creating a physical body that is in equilibrium as well as dynamically off balance.

The Cathedral Evening is a symmetrical structure formed by two wedge-like volumes that support two cantilevered arms that come together like a pointed arrow; the sculpture consists of an inner wood frame of bolted two-by-fours paneled with plywood. Typically, Bladen would sketch a general diagram to better size the wood framing elements, then he would begin construction, verifying directly in situ the overall stresses, adding or subtracting parts from the rather chaotic inner framework. Peering inside the volumes of the work one is faced with an intricate skeleton of wooden pieces bolted together after a series of additions, and it is difficult to comprehend which are the essential parts holding the entire structure in place. The building of an inner wood frame encased by a volumetric shape that has no geometrical relationship to its core and can grow by additions exemplifies the structural freedom allowed within the balloon-frame building method typical of North American architecture.

The Cathedral Evening has a stark appearance, but approaching it one perceives its handcrafted nature still visible in the plywood seams that lie beneath its coat of black enamel paint. Bladen would remind the viewer infatuated with the industrial edge of a Donald Judd or Larry Bell that he was making sculpture, not furniture. The cantilevered arrow-like shape establishes a triangular spatial tension between the two base modules, which ironically seem to float just above the floor, creating a void between them and the surrounding architectural space. *The Cathedral Evening* by its very name reveals the romantic associations that differentiate it from most Minimal sculpture.

"I am more interested in the totality of the form of a sculpture than in the peripheral phenomenon of its details or in what can be written, thought or imagined about it. For me, the sculpture should be a natural phenomenon, which I can approach in order to feel, in order to be moved, inspired. And which contains a visible dignity and impressiveness, as a result of which it can never be anything else."

Ronald Bladen

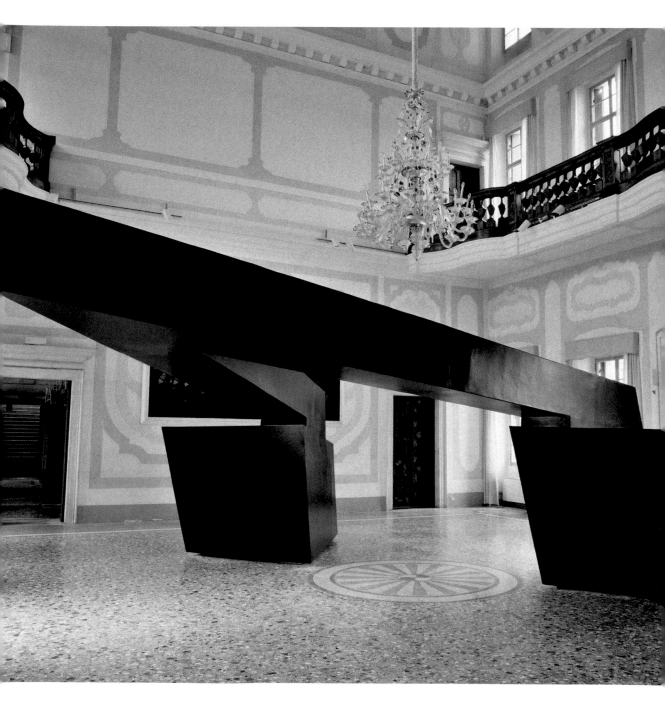

gothic shaped Drawing

Paper on metal frame, 62 x 35 cm

Berlin, Staatliche Museen zu Berlin – Preußischer Kulturbesitz, Nationalgalerie, Collection Marzona

b. 1935 in Albany (NY)

The work of Walter De Maria cannot be identified as belonging to a single artistic tendency or group. In the sixties his oeuvre crossed paths with Land art, Conceptual art and Minimal art and throughout his career De Maria has worked concurrently in very different directions. Many of his early works reveal a Dadaist sense of irony which is best exemplified in his *Boxes for Meaningless Work* (1961). The boxes are inscribed on the base with the following instruction to the viewer: "Transfer things from one box to the next box back and forth, etc. Be aware that what you are doing is meaningless."

De Maria's later works often present a premonition of dramatic events in nature that cannot be explained by reason, but still can be experienced by the observer. He can achieve this both in the open air and indoors in controlled installations. Think of his *Lightning Field* (1971–1977) in New Mexico, or the New York *Earth Room* (1977), for example. Focusing on the transition from concept to experience, De Maria aims to visualize the idea either in a subdued or extreme form, allowing the observer to fully experience it. *Gothic Shaped Drawing* is a visually silent work communicating an idea by its simple physical being. The formal configuration is that of a rectangular white sheet of paper with two corners removed at the top to form an arch. The resulting shape forms an abstraction resembling an ogive, a pointed arch form which was one of the recurring geometrical elements in Gothic architecture and painting: it was either a single entity or part of a series; pointing upwards, it was a reflection of man's yearn-ing to be closer to the divinity and the absolute. Consequently, man Gothic painters used the ogive shape to portray saints or knights. Th paintings were then displayed in shallow niches protecting the image of the saints and other artistic visions of the contemporary world. Mos Gothic art had a strong religious as well as political character.

De Maria's *Gothic Shaped Drawing* is an opaque white shiel that makes one wonder if anything might be on the reverse side Apart from its shape, any iconic reference has been withdrawn. Th drawing can be seen as an investigation into the human notion of th sublime and to that end, has an unusually strong presence for some thing lacking direct visual or linguistic signs. A simple outline and precise title are the means De Maria employs to define the conceptu al and rather mysterious terrain the viewer is invited to explore. Like religious symbol or a philosophical question, the piece challenges th observer, who is compelled to investigate its meaning as well as h own existence in the phenomenological reality they both temporari share.

"Eye + mind ÷ mind – Eye"

Walter De Maria

The Nominal Three
(to william of ockham)

Fluorescent light fixtures with daylight lamps, each 244 cm, overall dimensions variable, edition 2/3
New York, Solomon R. Guggenheim Museum, Panza Collection, 91.3698

**b. 1933 in Jamaica (NY),
d. 1996 in Riverhead (NY)**

When it first appeared in New York galleries, Dan Flavin's work was somewhat ill received even by the most progressive critics of the time. Lucy Lippard found Flavin's use of coloured light "too beautiful" and declared that his works were crossing the border into decoration.

David Bourdon compared Flavin's first exhibition at the Green Gallery in New York to the shop window of a lighting company. Like the work and materials of other Minimalists, Flavin's tubes did not seem to be noble enough at the beginning of the sixties. *The Nominal Three*, first installed at the Green Gallery in 1964, is perhaps the most paradigmatic among Flavin's works, marking the transition from a more pictorial use of light to one that relates to and alters the space it inhabits.

The Nominal Three is an arrangement of fluorescent tubes in a series of white units that follow the algebraic progression of $1 + (1+1) + (1+1+1)$, a simple formula of infinite counting arbitrarily stopped at the number three, the least number of elements needed to define a series. What is important about the formula is not its mathematical structure, but rather its serial existence as adjacent units. *The Nominal Three* is important for its progressive, serial procedure, which is a characteristic shared with other Minimal artists such as Donald Judd and Sol LeWitt, who also apply a methodically selected system to their work. The white units bring measure, order and unity to their space, while at the same time dematerializing its actual physicality.

There is an allusion in Flavin and other Minimalist artists' works to the paintings of Barnett Newman (1905–1970), particularly *The*

Stations of the Cross (1958–1966), which uses seriality as an integral part of its ultimate conception. *The Stations* consists of 14 individual works painted over eight years that together form the series. Th simplicity and wholeness of Newman's approach to painting finds it echo in the work of Flavin. Newman's "zips" may be seen as predecessors of Flavin's luminous zips of light. Both artists tried to reduc their work to its essentials.

The Nominal Three can be exhibited in different rooms with differing dimensional lengths to the tubes, but always must be shown i units totaling three, evenly spaced on the wall. This is because Flavi dedicated *The Nominal Three* to the 14th-century Nominalist philosopher William of Ockham (or Occam), who is best known fo "Occam's Razor", namely the statement that "entities should not b multiplied unnecessarily", which set a new course for medieval philosophical thought. Flavin attempts to do the same, setting a ne course for his art.

> **"individual parts of a system are not in themselves important but are relevant only in the way they are used in the enclosed logic of the whole."**
>
> Dan Flavin

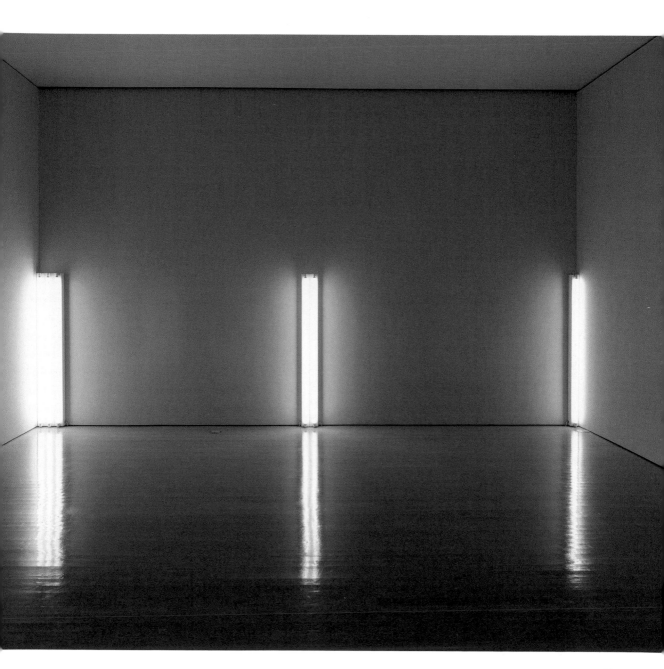

The Diagonal of May 25 (to constantin Brancusi)

Cool white fluorescent light, 244 cm
Private collection

Dan Flavin began his career as an artist in the late fifties with abstract paintings that revealed the clear influence of the gestural abstraction of Robert Motherwell (1915–1991) and Franz Kline (1910–1962). In 1961 the artist started to explore new territory, experimenting with electric lights. He began to attach light bulbs and tubes to boxes hung on the wall. He called these rather obscure works icons.

On May 25, 1963 he had his artistic breakthrough when he attached a single fluorescent tube diagonally to his studio wall: *The Diagonal of May 25 (to Robert Rosenblum)*. From that moment on, Flavin began to use everyday light fixtures as his only material and medium. They are given objects, industrial ready-mades that he does not alter structurally or functionally. Instead, he uses the limitations of the medium to extend the concept of light, how it functions, and how we perceive it. Within this simple concept, he challenges the configuration of the space the work is going to occupy in a highly complex way.

When delineating a "proposal" for a specific place, Flavin often uses combinations of tubes arranged in simple series that expand into the exhibition space. Corners lose their function as in *Pink Out of a Corner (to Jasper Johns)*, 1963, for example. In his early works with fluorescent light, Flavin reveals a puritan simplicity, using few elements and placing them in unnoticed corners or portions of walls. *Untitled* (1964/1974) is composed of a long, thin, white tube and a thicker, shorter red one centred directly below and placed horizontally on the wall. It has a pale fuchsia colour due to the convergence of the white and red lights. The pink glow alters the perception of the room's space and the almost visible vibrations of light inside the fluorescent tube extend to the surrounding architecture, coating it with a layer of pulsating light. People within the space experience a metamorphosis of skin shade as well as a stillness around them. Sound becomes dulled until the only noise heard is the vibration of the gas in the electrified tubes. The horizontal positioning at eye level gives the object the status of reference point within the now indefinite atmosphere of the room. The fluorescent tube and the wall thus become a single new entity. There is a sense of absoluteness in the experience of Flavin's work and, at times, a violence in the radically dislocated space.

In fact, Flavin diffuses light in formations that sometimes can be optically and sensorily depriving for the viewer. In the monochromatic installation *Greens Crossing Greens (to Piet Mondrian Who Lacked Green)*, 1966, a linear sequence of freestanding fluorescent fixtures acts as a barrier impeding physical access to part of the space. This acts in full accordance with Flavin's original desire to "disrupt" the space of the room.

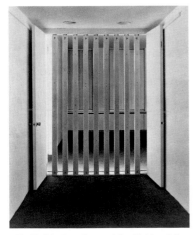

Untitled (to Dorothee and Roy Lichtenstein Not Seeing Anyone in the Room), view of installation, Dwan Gallery, New York 1968

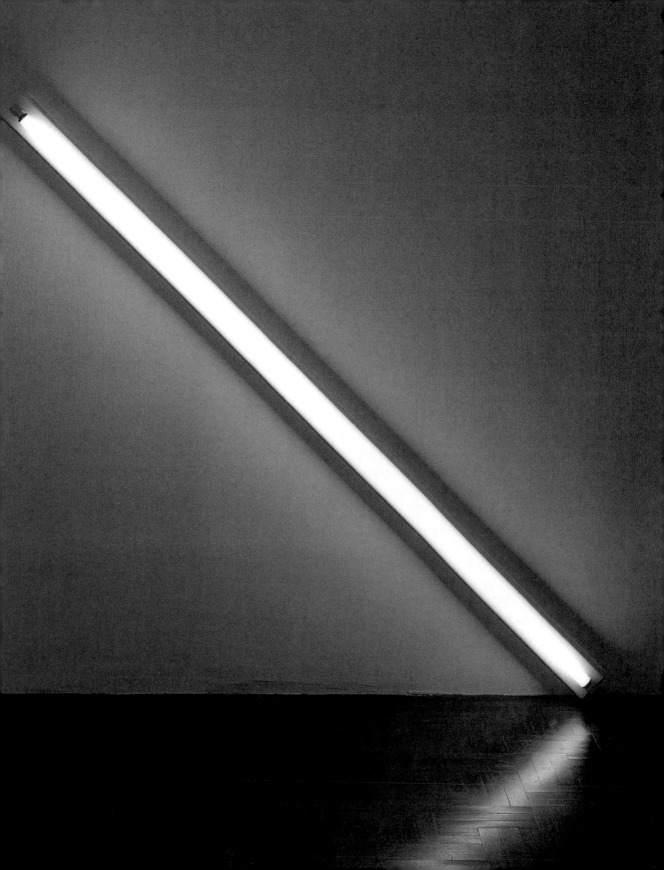

untitled

Wood, steel, 121 x 274 x 274 cm
Private collection, Italy

b. 1937 in New York (NY)

Robert Grosvenor's early works of the sixties were big plywood volumes cantilevered dramatically across the exhibition space, typically hanging from the ceiling, bending on the floor, or extending from the wall at waist level. They had many similarities with Ronald Bladen's works in that both artists were interested in gravity, dynamism and the environmental dialogue between sculpture and architecture. Both artists exhibited at the Park Place Gallery and the Green Gallery in the early sixties, and they were lifelong friends. Grosvenor's work became well known to a wider audience after his participation in the groundbreaking "Primary Structures" exhibition in 1966. Many critics of the show preferred Grosvenor's dramatic and monumental approach to sculpture to the more austere objects of Donald Judd, for example. Bladen's *Three Elements* and Grosvenor's *Transoxiana* (both 1965) were among the most celebrated works on display.

Grosvenor later created monumental works of art which the public could walk around and under, but his stated purpose early on was not to overwhelm the viewers, but to make them aware of a suspended dynamism present in the room or space. In the early seventies Grosvenor investigated timber in his sculptures, searching for the material's essential qualities independent of any utilitarian factors. He used long beams, but also wood telephone poles, stressing and breaking their fibres to challenge their physical nature. It was an investigation into the notion of transformation and the aesthetic power of liberated energy. There is loss of energy in each modifica-

tion, but for Grosvenor the transformation itself, as a process, was his subject matter.

36 dark timbers tightly assembled to form a cuboid volume whose top edge is slightly above eye level, form *Untitled*. Each of the four sides of the square is characterized by four rows, two formed by the timbers seen sideways on, the other two by timbers seen end-on. Grosvenor seeks to avoid any particular compositional or hierarchical quality among the parts of the ensemble, which is based on a simple stacking scheme. In fact the timber grain and surface are not particularly suitable for the arrangement of the block configuration. Their surfaces have been only roughly planed in a simple, primitive manner creating a variety of lights and darks in the shadows and gaps between the individual forms. When situated in a room, *Untitled* affects its surroundings; by compressing the area between itself and the planar surfaces of the room, a previously unnoticed space asserts its own existence. There is no particular force applied to the sculpture aside from the lifting involved to stack and install it. The block weighs down on the floor simply by the effect of gravity – a literally minimal means of installation.

"My works are ideas which operate between floor and ceiling."

Robert Grosvenor

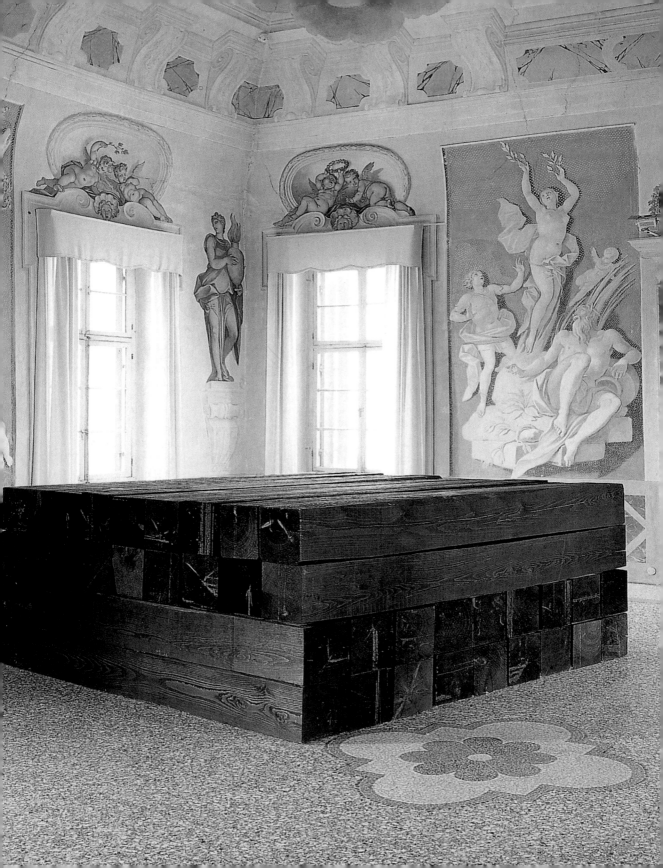

ACCESSION III

Fibreglass and plastic tubing, 80 x 80 x 80 cm
Cologne, Museum Ludwig

> "Life doesn't last; art doesn't last.
> it doesn't matter ... i think it is both
> an artistic and life conflict."
>
> Eva Hesse

b. 1936 in Hamburg (Germany),
d. 1970 in New York (NY)

Born in Hamburg in 1936, Eva Hesse had to emigrate with her family in 1938 and arrived in New York in 1939. She studied painting there at the Cooper Union School of Art as of 1954. Between 1954 and 1957 she painted her first Abstract-Expressionist works. In 1957 she began attending courses at the Yale School of Art and Architecture, where she was taught by Josef Albers. In addition to Informel and serial paintings, Hesse produced numerous objects made of the most varied of materials. In the short span of time between 1964 and her death in 1970, she produced an oeuvre of about 70 works which took up and reinterpreted the paradigms of the then dominant art movements Pop Art and Minimal Art – serialism, repetition, raster patterns, the cube, the use of industrial materials and processes. The fragile and seemingly organic materiality of Hesse's works humanise the cool austerity of minimalist object art.

In 1967 Hesse first used professional help in producing an object, for the series *Accession.* She had open topped metal or Plexiglas cubes made in which – depending on the size – up to 8000 holes were punched. Probably to re-establish the balance between own and outside production, she threaded short pieces of plastic tubing through these holes, an obsessive process that involved months of work. This resulted in small taut loops on the outside of the cube that give the impression of weaving; inside, by contrast, the ends of the tubing create a brush-like surface. This formal contrast between outside and inside, tamed and wild structure, hard shell and soft kernel, conjures up all sorts of associations.

Expanded Expansion reveals further levels of meaning in Hesse's art. Semi-transparent upright fibreglass rods at irregular intervals are leaning in a row against a wall. Hesse stretched elasticated gauze between the rods. To a degree, the width of the sculpture is variable, depending on how far the rods are separated from one another. By allowing fibreglass to harden on different cardboard tubes and then removing the hardened mass from the tubes, Hesse emphasised the individuality and distinctiveness of elements that only seem identical at first sight and whose uniqueness is emphasised in the skilled personal production process.

Currently *Expanded Expansion* can no longer be exhibited, as important parts of it have deteriorated so much that the sculpture could collapse. A controversial debate is in progress as to whether it is permissible to reconstruct these works. Opponents of such an undertaking allude to the fact that the artist was aware of the ephemeral nature of the materials she used. From this perspective the materiality of Hesse's works points to the motif of vanitas. Her oeuvre can be understood in terms of a life conflict borne out in art and characterized equally by happiness and loss, a conflict in which the absurdity of her time becomes visible – an artistic whole made up of fragments.

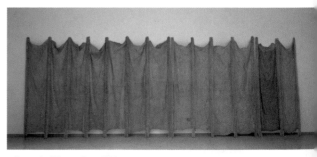

Expanded Expansion, 1969

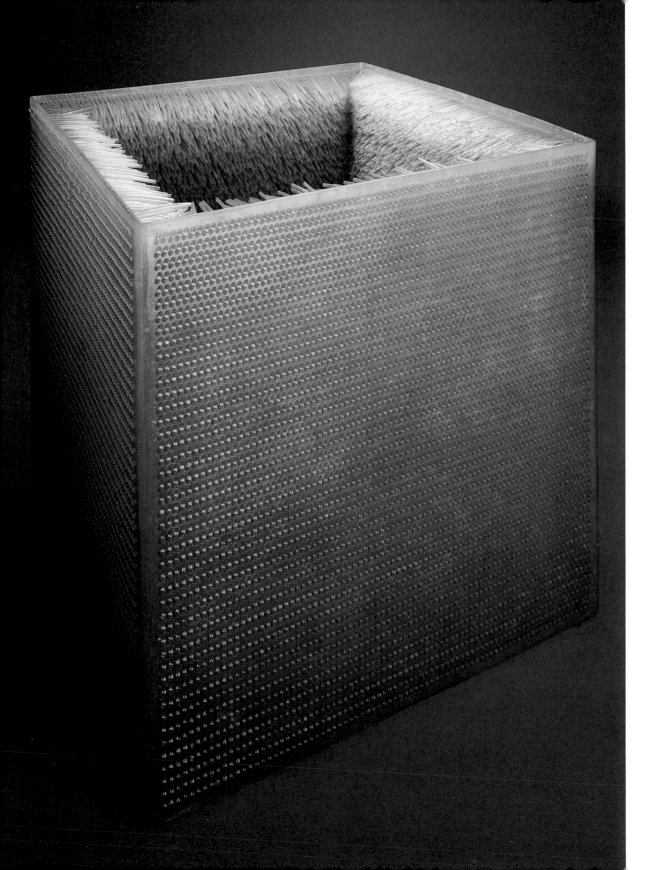

untitled

Copper, 10 units, each 23 x 101.6 x 78.7 cm
New York, Solomon R. Guggenheim Museum, Panza Collection, 91.3713.a–.j.

**b. 1928 in Excelsior Springs (MO),
d. 1994 in New York (NY)**

The almost square, highly polished piece of stainless steel and Plexiglas, *Untitled* (1968), is installed at just above eye level on the wall. This establishes a relationship to the viewer. Its mirror-like surface reflects the space it is in, while the orange Plexiglas top and bottom add an element of warmth to the cool steel exterior. *Untitled* is one independent unit and stands alone, but the form could have been singled out from among other pieces by Donald Judd, for example his *Untitled* from 1969, ten copper units. This reflects an important aspect of Minimal art, the relative independence of its forms from the tyranny of dependent, fixed relationships. Sculptures could be arranged serially or not, depending on the wishes of the artist. In Judd's case, some of his pieces have been shown with a different number of elements in keeping with the restrictions of the given space. Seemingly autonomous, his works cannot be perceived without considering their relationship to the space they occupy and influence.

The meticulous installation of his works was always of great importance to Judd, who often complained about the temporary and improvised nature of gallery shows. In 1971 he discovered the small town of Marfa in Presidio County, Texas. From 1973 to 1984 he realized, with the help of the Dia Art Foundation, one of the largest art projects ever undertaken by a single artist. By the late seventies Judd had also begun to centre his private life on Marfa, and started to live there with his two children.

Following disagreements with the Dia Art Foundation, the place was transformed into The Chinati Foundation in 1986. In vast indoor spaces and large-scale outdoor installations, Judd created a perfect environment for his and some of his contemporaries' work. At the former military base of Fort D. A. Russel in Marfa, Texas, the visitor will find many of Judd's major and early works, as well as important pieces by John Chamberlain (b. 1927), Dan Flavin, Carl Andre, Roni Horn (b. 1955) and others permanently on view.

Judd first started using Plexiglas in 1964, which complicated the perception of his pieces greatly. From then on a play began between open and closed volumes, mass, reflections and transparency undermining the simplicity that Judd theoretically held so dear. Compared with the Minimalist works of Robert Morris dating from the same period, his works had a lot more to look at and became increasingly complex. As with Larry Bell, Dan Flavin and other artists during the sixties, their decision-making process was restricted by the limited colour choices commercially available, which constituted yet another welcome removal of the "artist's touch". The industrial world decided the colour choices, not the art world.

Untitled, 1968

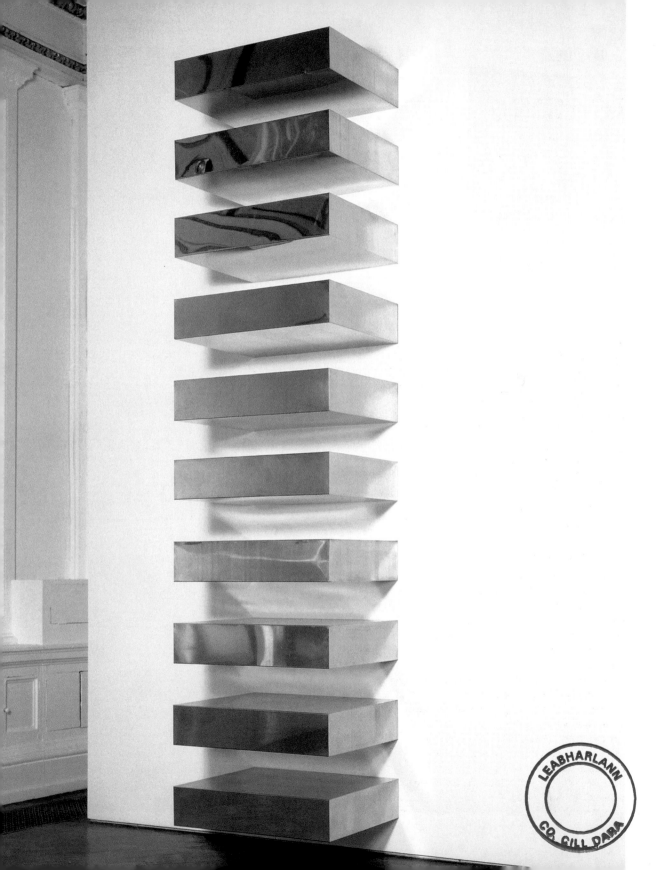

untitled

Aluminium, blue Plexiglas, 100 x 50 x 50 cm
Berlin, Staatliche Museen zu Berlin – Preußischer Kulturbesitz, Nationalgalerie, Collection Marzona

Donald Judd had received a remarkable academic education during the fifties and sixties. He spent 15 years at several universities, not only studying art, but also acquiring degrees in art history and philosophy. Together with Robert Morris, Judd soon became the leading theoretician of the new work in three dimensions. His essay "Specific Objects", which was first published in 1965, has been considered by many art historians as the first manifesto of Minimal art. The opening line, "Half or more of the best new work in the last few years has been neither painting nor sculpture", is one of the most quoted artist statements in recent art history.

Different from many other Minimalists, Judd never abandoned the relief format, and many of his works retained a clear relationship to the wall. *Untitled* is mounted on the wall at eye level, and the divided front surface of the steel and Plexiglas rectangle gives it a dual visual presence. Depending on the intensity of the light, the blue side can appear denser and more reflective as a frontal surface, or else more transparent and vulnerable.

In spite of its rather complex visual demands, someone could look at this piece, and without touching it, determine the exact dimensions, materials needed and approximate weight of the sculpture in order to effectively reproduce it. This is in keeping with Judd's stated desire to not hide the process or materials of his objects. The notion of wholeness, which was very important to Judd, was in his mind independently of the fact that a work consisted only of one or more elements. Since there are no hierarchical relationships between their parts, Judd considered not only works like *Untitled* but also his *Stacks* as aesthetically whole.

The blue Plexiglas left-hand side, when seen next to the steel right-hand one with only the joined edges exposed, recalls the compositional structure of certain Minimalist paintings by Robert Mangold and Paul Mogensen (b. 1941). The cut-out replacement of steel on the left side and its replacement by Plexiglas represent another aspect of the modular, serial procedure of most Minimal art. Its forms can be self-generating like an organism reproducing itself. The frank confrontational look of *Untitled* is inherited, but by no means copied from sculptors like Tony Smith, who began to produce austere, simple and sometimes mysterious works in the early sixties, but did no exhibit them in New York until 1966. Smith's cubes and complex polyhedra hover on the ground, while Judd's *Untitled* is placed right up literally in your face.

"The first fight almost every artist has is to get clear of old European art."

Donald Judd

untitled

Steel, 6 units, overall 300 x 50 x 25 cm
Berlin, Staatliche Museen zu Berlin – Preußischer Kulturbesitz, Nationalgalerie, Collection Marzona

Donald Judd has often been considered as the Minimal artist par excellence. He started his artistic career in the late forties as a traditional painter and developed his mature work at the beginning of the sixties out of his experiments with painting. In 1961 and 1962 Judd executed several reliefs which combined elements of painting and sculpture. In 1963 he gave up painting altogether and focused his attention on work in and with real space. Curiously, Judd had worked out the concept of his "specific objects" more or less unnoticed by the public. In spite of several invitations Judd refused to show his work publicly from 1958 to 1962. During this period he was much better known as an art critic than as an artist. Judd wrote articles and reviews on a regular basis for "Art News", "Arts Magazine" and "Art International" and these reviews soon became famous for their abrasive style and rough, uncompromising criticism. When Judd first exhibited his three-dimensional work at the Green Gallery in 1963, even the insiders of the New York art world were surprised by the austerity and vaunted simplicity of his objects.

Untitled is a vertical wall progression of six rectangular steel boxes with equal spacing between each box, a structural form first used by Judd in 1965. The so-called *Stacks* soon became a signature style of Judd's work. The boxes are identical within the limits of welded fabrication. In fact, beginning in 1964, Judd employed the industrial manufacturers Bernstein Brothers to make his works for him, and in one fell industrial swoop discarded artistic sentimentality and all traces of the artist's hand. In *Untitled* the rectangles are open at the front and reveal their interior to the viewer. This creates an aesthetic honesty that Judd desired and used in order to eliminate the element of illusionism so abhorrent to him in his work and convictions. He believed the observer should be able to see how the piece was made and immediately understand its structure.

From the mid-sixties on, Judd used his *Stacks* and progressions in either a horizontal or vertical direction, varying the number of forms anywhere from one to ten. The ochre surface of this piece reflects Judd's attention to unified colour. As a former painter he ha very distinct ideas about how to use colour. In his lacquered aluminiu and metal pieces he used colour in both matt and glossy finishes. *Untitled* (1987) he used galvanized iron and turquoise Plexiglas in te units at 15.24 cm intervals. Other works employ Corten steel (Douglas fir and plastic. Using newly invented and improved tech niques of colouring metal, like anodizing and lacquering, Judd wa able to meld the colours with the surfaces so they became one wil each other.

Untitled rises majestically up the wall. The effect Judd achieve in pieces like this defines the public idea of Minimal art to a larg extent. Clean, efficient lines, the use of modern industrial materials, r sign of the artist's hand and a sense of wholeness are the definin principles of Judd's "specific objects".

> **"A shape, a volume, a colour, a surface is something itself, it shouldn't be concealed as part of a fairly different whole."**
>
> **Donald Judd**

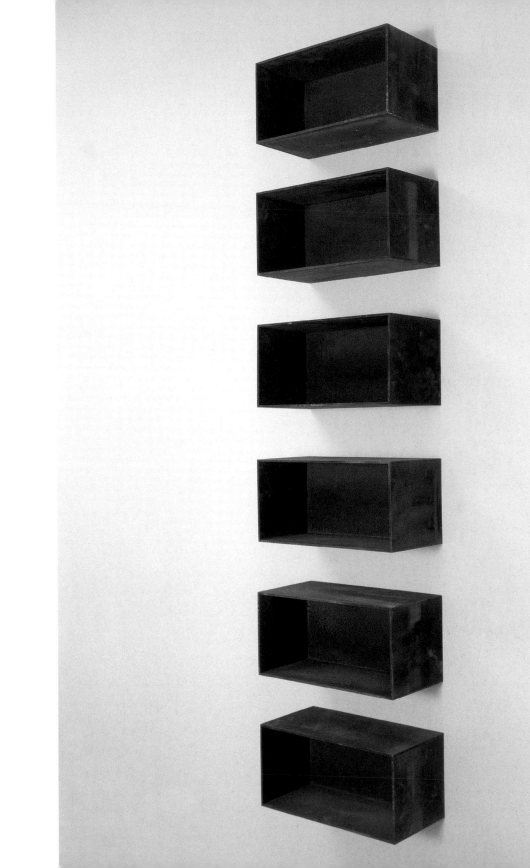

untitled

Fibreglass and wire, 22 x 80 x 10 cm
Berlin, Staatliche Museen zu Berlin – Preußischer Kulturbesitz, Nationalgalerie, Collection Marzona

b. 1939 in Plainfield (NJ)

Gary Kuehn studied with Roy Lichtenstein (1923–1997) and George Segal (1924–2000) in the early sixties. He received his MFA from Rutgers University, New Jersey, in 1964. Much of Kuehn's work stems from his private psychological needs and experiences. During the sixties Kuehn worked on huge construction sites where he took on the most dangerous jobs either as a structural steel worker or as a roofer. Here he witnessed small engineering disasters that influenced some of his early works. Many of his foam pieces of the late sixties allude to these disfiguring accidents in a surreal manner. Kuehn's fibreglass works have been included in many important group exhibitions, such as "Eccentric Abstraction" (New York, 1966) or "Live in Your Head: When Attitudes Become Form" (Bern, 1969).

Untitled appears as a rectangular, malleable, rubber-like form lying on its side and tied tightly about its abstract "neck" by steel wire. The wrinkled and bulging surface seems to push outward from underneath the wire-like skin. There is, in spite of this, a humorous aspect to the piece. It looks like a block of American cheese wrapped in Kraft paper being punished, or about to be kidnapped: another small engineering disaster in the making. The anthropomorphic quality is emphasized by the fact that the steel is tied at what could be considered the neck of the piece. The evident contrast between its vaguely organic sensuous shape and the cold, impersonal steel wire is even more deceptive when it is noted that the soft-looking surface of the sculpture is an illusion.

Untitled is made of rigid synthetic fibreglass material modelled to resemble a pliable surface. Thus the physical nature of the work is in contrast with its visual appearance; the real bondage and the imagined act of release create an ambivalent struggle between reality and imagination. Many of Kuehn's works subvert the power of pure form to assume a new kind of surrealist and expressionist attitude. His art can be grouped together with the post-Minimalist tendencies of Eva Hesse, Keith Sonnier (b. 1941) and late Robert Morris. Kuehn constructs geometrically simple and benign forms, and then he breaks them open, exposing a physical disruption of the integrity and structure of the piece. He investigates the vulnerability of structures and their resultant changeable condition by variously splitting, compressing and expanding the materials to permanently alter their physical status. All this is usually done on an intimate scale that heightens the surrealist aspect.

Untitled, 1969

wall structure –
Five models with one cube

Lacquered steel, 341 x 73 x 30 cm

Berlin, Staatliche Museen zu Berlin – Preußischer Kulturbesitz, Nationalgalerie, Collection Marzona

b. 1928 in Hartford (CT)

A ladder-like object created with a linear sequence of five squares with a three-dimensional cube projecting outward one interval below the top of the line: *Wall Structure – Five Models with One Cube* marks a transition from individual, hand-made works to the serial pieces from 1966/67 that soon led to a radically conceptualized and methodical approach to art and the making of objects.

Sol LeWitt has determined beforehand the overall measurements as well as the ratio between the visible cubic space and the square models. The work is considered a wall piece, but its horizontal or vertical placement on the wall surface is not defined. It is the installer's decision and responsibility to choose the hanging direction; thus LeWitt refrains from imposing a system on his system. *Wall Structure* is one of many possible configurations in a broader sequence LeWitt could have realized; the cubic extruded frame, located in a different position within the square series, would redefine the configuration of the structure without changing its overall dimensions. LeWitt's modular work could be related to Carl Andre's *Cuts*, 1967, where three-dimensional voids with diverse shapes but identical volumes are subtracted from the compact mass covering the entire floor of the Dwan Gallery.

The multiple permutations LeWitt develops in his pieces are manifestations of a geometrical and mathematical system based on predetermined parameters, as well as derived from common industrial materials like aluminium, steel sections or concrete blocks. LeWitt considers the planning and generation of the sequential scheme the

work itself, thus its material execution is not a necessary act an could be realized by anyone according to the artist's specification. The physical object is secondary to its generative concept.

This principle is best exemplified in LeWitt's "wall drawings begun in 1968. The first "wall drawing" was executed by LeWitt him self at the Paula Cooper Gallery, but soon assistants and the artist' friends were enlisted to draw them directly on gallery or museur walls all over the world, following the artist's clear instructions an specific drawing. The same work could be realized repeatedly in di ferent locations and could look different depending on the limitation of the actual wall.

Although the works of LeWitt seem to follow logical principle: his premises and concepts are often completely irrational. Accordin to the artist there is no contradiction, since "irrational thoughts shoul be followed absolutely and logically". LeWitt's white framework adopt a geometric system of coordinates which exists in the viewer's ow space, thus representing a conscious decision to maintain a direc relationship to the public realm: the viewer is intended to be aware c his own self during the act of perception, which is an important con ponent of the work itself.

> **"The form itself is of very limited significance; it becomes the grammar of the whole work."**
>
> **Sol LeWitt**

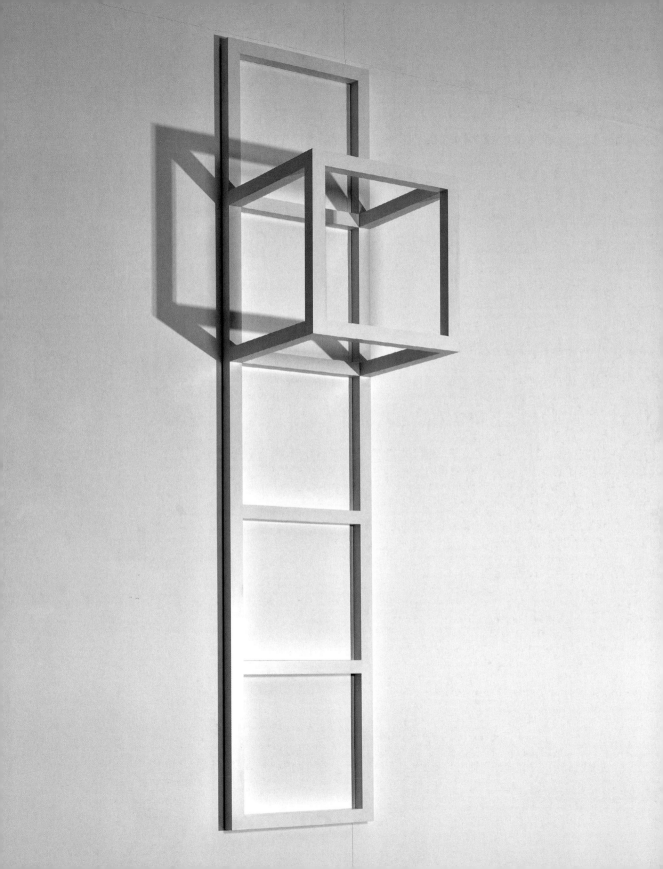

open cube

Lacquered aluminium, 105 x 105 x 105 cm
Berlin, Staatliche Museen zu Berlin – Preußischer Kulturbesitz, Nationalgalerie, Collection Marzona

The work of Sol LeWitt in the sixties must be regarded as exceptional since it bridged the gap between formal abstraction and Conceptualism. Within a few years between 1964 and 1967, the work of LeWitt underwent dramatic changes. After he had given up painting a year earlier in 1963, LeWitt worked on single objects mostly built out of plywood. These reduced structures were either hung on the wall or placed directly on the floor. In 1965 LeWitt developed his first modular structures based on the cube format. From then on his works were all coloured white and mostly built by factories in steel or aluminium. One year later LeWitt began his first serial projects and abandoned the Minimalist, object-based discourse. He became one of the first conceptual artists working in New York. In 1967 LeWitt wrote and published his "Paragraphs on Conceptual Art", a short text in which he clarified the theoretical guidelines of his artistic approach.

Open Cube belongs to LeWitt's early investigations into the infinite possibilities of defining a cubic space from a freestanding three-dimensional frame, and is one of his early modular works. The work is the skeleton of an open cube lacquered a ghostly white, giving it an air of immateriality. It defines a portion of space within as well as around itself, its dimensions and shape having been predetermined by LeWitt within a set of personally determined parameters. The cube configuration is a physical module deriving from a numerical equivalence (1 x 1 x 1) that mathematically defines the dimension of a cubic metre, but alone could not indicate all the possible visual and material configurations the cube can have. By removing the skin of the module LeWitt had to find a system he could build within, and in 1966 he began to use a nine-part grid as his standard. In a text accompanying his first serial project *ABCD* (1966), LeWitt described how serial compositions can be regulated to effect changes. These changes are within the whole, but their individual permutations then become the subject matter.

His oft-mentioned early admiration for the pioneer photographer of the moving image Eadweard Muybridge (1830–1904) is still visible in 1968. The cube seems to be in motion despite sitting still on the floor. Its upper horizontal white edge seems to be moving across the top, about to head both down and across in the act of completing itself. *Open Cube* can be understood as the physical expression of the essence of a cube. It is open to the space of the room, with its inner space and the surrounding space merging at the white frame.

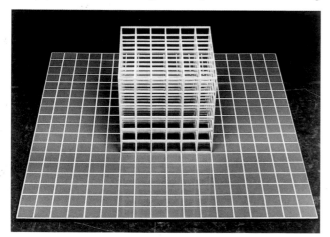

Modular Cube/Base, 1968

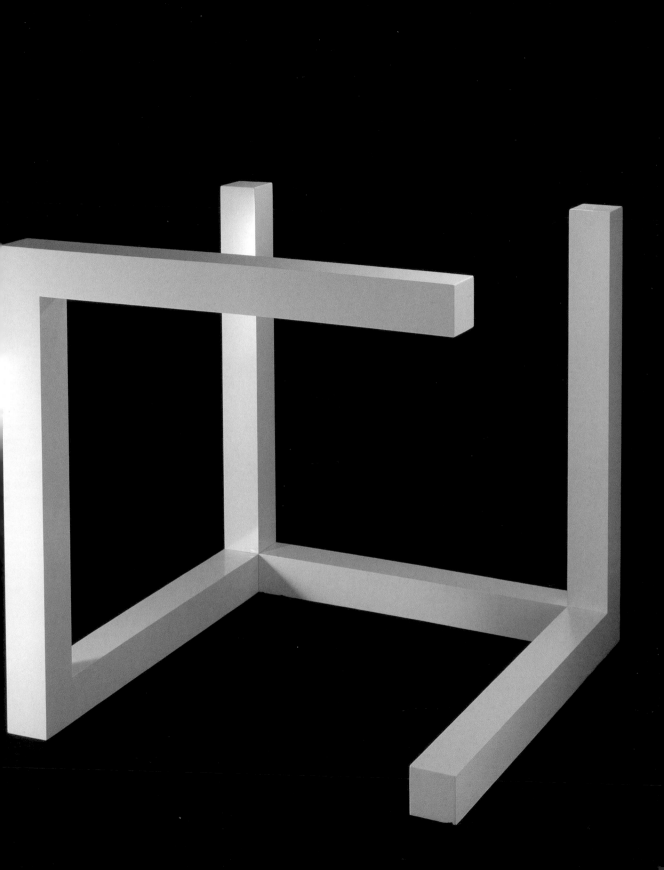

HRZL 1

Concrete blocks, 160 x 160 x 720 cm
Private collection, Italy

In the mid-eighties Sol LeWitt began a new series of works using concrete blocks. The artist was interested in the "non art" quality of the material, and also welcomed its practical advantages, since "concrete blocks are basically the same all over the world". Indeed one can find LeWitt's concrete cubes, towers, pyramids and geometrical progressions almost anywhere in the world where concrete blocks are used. In stark contrast to his open cubes and modular structures, these works are built of layers of massive volumes, but appear no less architectural than his earlier structures. Some of LeWitt's concrete works, like his *Eight Columns in a Row* (1995) at Schiphol Airport, Amsterdam, have reached quite gigantic dimensions, while most remain within the usual scale of outdoor sculpture.

HRZL 1 is composed of concrete blocks and follows a geometric progression beginning with one cubic block of 20 x 20 x 20 centimetres and terminating with a cube of 160 x 160 x 160 centimetres,

with each unit of the stair-like configuration aligned on the central axis. The smallest unit determines the ultimate series of outward progressions. The work is the realization of a numeric and geometric sequence of incremental units with the smallest concrete block as the beginning of a sculptural entity defined within a public space; part barrier, part raised plateau, *HRZL 1* is the beginning of a modular series still in accordance with his statement from 1967: "When an artist uses a multiple modular method, he usually chooses a simple, limited and readily available form. The form itself is of very limited importance: it becomes the grammar for the total work."

HRZL 1 when seen outdoors is an architectural form apart from nature. Inside it would have a different appearance; like many works of Carl Andre made of sand-lime, firebricks or metal plates, it would become a kind of architecture within architecture. Similar to Andre's works, LeWitt's concrete structures are themselves composed of smaller units placed together to make the progressively large forms, yet unlike Andre's works, *HRZL 1* cannot be dismantled without being destroyed. Like the *Endless Column* by the Romanian sculptor Constantin Brancusi (1876–1957) placed on its side, the modular structure could extend out indefinitely. It follows LeWitt's earliest ideas about variations available within an original premise and illustrates the endless variations possible within the basic cube and square form.

> "The aim of the artist would not be to instruct the viewer but to give him information. …
> The serial artist does not attempt to produce a beautiful or mysterious object but functions merely as a clerk cataloging the results of his premise."
>
> Sol LeWitt

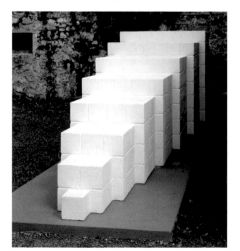

HRZL 1, 1990

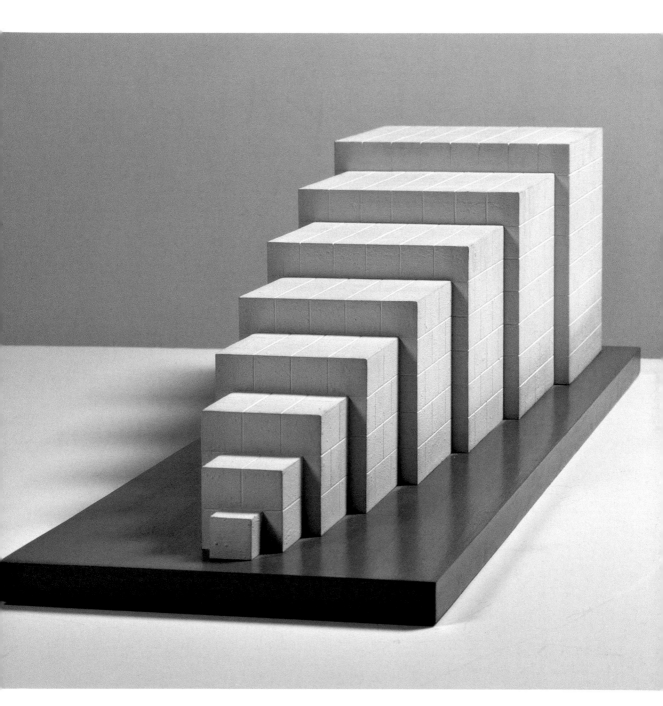

Distorted square/circle

Pencil on cardboard, 9 parts, each 28 x 21.6 cm
Berlin, Staatliche Museen zu Berlin – Preußischer Kulturbesitz, Nationalgalerie, Collection Marzona

b. 1937 in North Tonawanda (NY)

Robert Mangold received his MFA from the Yale University School of Art and Architecture in 1963. Together with Robert Ryman, Mangold was among the few artists starting their career in the sixties who retained a strong interest in the underestimated possibilities of painting. At a time when many artists considered painting dead, and working in three dimensions became the most exciting arena, Mangold kept on working within the flatness of the picture plane. In his mind the two-dimensional nature of painting represented not a limitation but an advantage since "flat art can be seen instantly, totally".

In the mid-sixties Mangold developed his famous series of *Walls and Areas*, which he first exhibited at the Fischbach Gallery in 1965. The *Walls* usually consisted of two separate shaped wood or Masonite panels which were spray-painted in a monochrome tone and hung next to each other. Most of these works clearly referenced architectural elements like windows, walls or corners. Although to a certain degree allusive, these early works already reveal Mangold's focus on the four independent but related elements of painting; shape, colour, line and surface.

Among Mangold's early-seventies drawings and paintings on paper or Masonite, there are many works where one solitary, geometric outline emerges from a monochrome background, similar to his series of individual circles placed within square canvases. *Distorted Square/Circle* is different.

Eight separate drawings on white-painted sheets of cardboard are placed together in a rectangle to form a complete piece (= 9 parts). Within each frame a square is drawn. Within each square a circle is drawn with compasses. But the similarities end there. The angles of each "square" are not right angles, and the circles within move around in each square. The circles stay within the borders of some squares, but because of the distorted angles, are cut off at the top, bottom, or left side of others. The title *Distorted Square/Circle* describes the action of the piece. What these distortions do within the frames is create depth and movement on what would ordinarily be a simple, flat surface of geometric pencil lines. The circles move the way the sun or moon does over the course of time and space in the earth's natural system, a counterpoint to the man-made, system-based world of this age.

"I've been more inclined to think about painting as a combination surface-shape rather than as an object."

Robert Mangold

тhree squares within a тriangle

Acrylic and pencil on canvas, 145 x 183 cm
Private collection

Some of Robert Mangold's later paintings and drawings, in particular the semicircular ones, are vaguely reminiscent of Frank Stella's (b. 1936) abstract pictures from the 1960s with their excised "punched out" middle pieces. Mangold's series with their individual circular forms on square canvases can also be compared with Sol LeWitt's "wall drawings" and Mel Bochner's (b. 1940) diagrams, or with abstract-geometric representations. Yet whereas LeWitt and Bochner's works rely on systematic schemata and are carried out on the basis of previously defined concepts, Mangold's paintings seem intuitive, like the findings of an individual investigation.

Mangold's use of shaped canvases, whose geometric forms are often imperfect, can be regarded as a constant feature of his painting. Sometimes rectangle, square and circle are scarcely distorted or cropped. They give expression to a fragmentation of the gaze, the source of which is Mangold's experience with the chasms between New York skyscrapers. By contrast, the artist associates curved outlines with the experience of nature.

Three Squares within a Triangle is a work from a series Mangold produced in the mid-seventies. Formally, these paintings are restricted to geometric shapes in different configurations mainly on monochrome canvases or masonite boards. The paintings are relatively moderate in size – the largest in the series measures 145 x 183 cm – and done using acrylic and pencil. This work is in the primary colour red, while in others he uses mainly subdued, light-absorbing colours like salmon pink, blue, green and dark grey. Three different size squares are engraved, as it were, into the geometric triangular form of the canvas in pencil, with the largest square standing on one of its corners so that it seems to disrupt the symmetry of the triangle. The question this raises is that of the beholder's gaze: where is the eye drawn to most, the figures on the canvas or the form of the canvas itself? Asked about the object-nature of his works, Mangold once said: "I've been more inclined to think about painting as a combination surface-shape rather than as an object."

Mangold bundles all the painting's elements on an apparentl flat plane, yet still achieves an impression of depth. It would seem as remnants of illusionism simply cannot be avoided in painting, eve when all the compositional elements are clearly and dispassionatel arranged. Unlike Donald Judd, Mangold sees no problem here, an has deliberately included a remnant of illusionist spatiality in the wor – not least to intensify the complexity involved in perceiving hi paintings. Mangold thus plays with the elements of shape, colour, lin and surface which are constantly changing in the eye of the beholde Seemingly schematic geometric forms unite in Mangold's paintings t create fluid, constantly changing fields of vision.

"ın the process of changing form-definitions, the visible loses its reliability. viewing is constantly thwarted, which results in a recognition of the unity of the work in its transcendence of the visible: in the tension of personal effort and processes of perception."

Robert Mangold

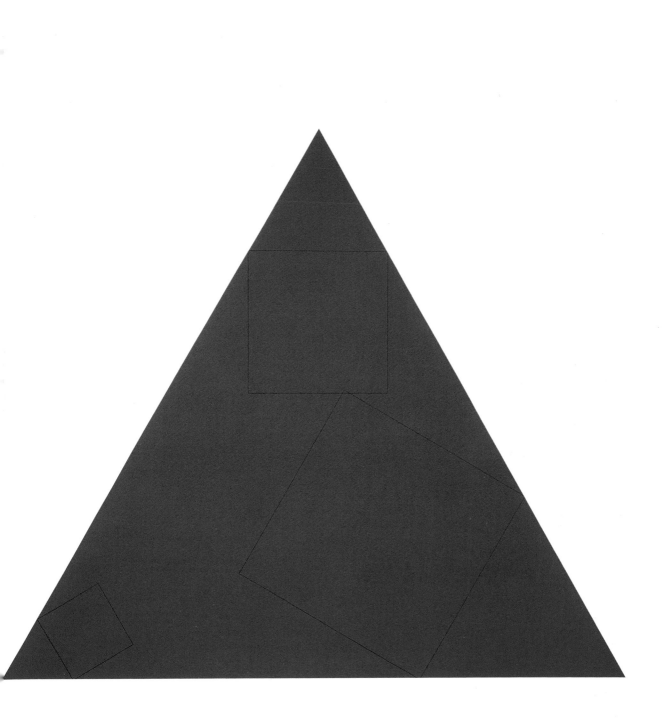

Right Down

Fibreglass and polyester resin on wood, 214 x 117.48 x 6.99 cm
San Francisco, San Francisco Museum of Modern Art, anonymous gift

b. 1934 in Berkeley (CA)

The native Californian John McCracken is usually identified with the "kustom kar" culture of Southern California because of the glossy, hard-body surfaces of his early work. *Right Down* stylistically follows the earlier pieces like *Blue Post and Lintel*, which are architectonic in character and painted a smooth, hard, cerulean blue, and block and slab pieces like *Black Black*. *Black Black* is more intimate in scale and painted a mirror-like black that gives it an iconic quality remininscent of the Kaaba, the sacred stone of Islam. Its frontal, squat nature calls to mind Tony Smith's *Die* (1962/1968), but only if the latter had been taken to California and dumped in a body shop for some major re-finishing. Its flawless, smooth surface is the complete opposite of Smith's piece and its size is much smaller. But like Smith's piece it is on a human scale and deals with an iconic space that relates not only to painting and sculpture, but also to other things beyond.

The effect of living on opposite coasts of the United States is noticable here; though McCracken's piece is black, it is not necessarily a "downer". Its perfectly executed forms and smooth exterior express perhaps introspection, but not despair. Its perfect craftsmanship and concern with structural reduction to essential form tie it to both the Minimalist school in New York and the new materials ethic of the California school of McCracken and his contemporary Craig Kauffman (b. 1932), for example. Both artists used fibreglass and polyester resin in shiny colours, unlike the reductive, simple and heavy materials such as steel or iron.

The "planks" sculptures such as *Right Down* began life in 1966 as sheets of plywood leaning against the wall in McCracken's studio. (Robert Motherwell's *Open Series* of paintings began life in a similar fashion; even the powder blue of *Right Down* alludes to Motherwell's work and shows how related to painting McCracken's aesthetic is.) The earliest plank pieces were 243.84 x 30.48 x 2.54 cm, the 2.54 cm width an attempt, it seems, to disassociate the wood itself from the standard size of 121.92 x 243.84 cm that plywood is commercially fabricated and available in. *Right Down* is pared right down to its aesthetic essentials, conveying its "facticity", a word so important at that time and spoken of by other Minimalist artists as inherent in the value of what they were doing.

For these pieces, McCracken covered the sheets of plywood in fibreglass and brightly coloured polyester resin so that colour became the overall structural quality of the work. Its facticity. Perceived primarily as a space of colour and light, but still physically present as an object, the planks can de-materialize when seen in the proper environment. Placed on the floor, they create a literal illusion of colour at human height and in our literal viewing and walking area. Their flatness also takes on painting's usual domain of illusionary colour and visual perception. In one sense it can be asked if this is a painting laid onto the floor? Such questions are appropriate to ask in the open realms of perception McCracken has created.

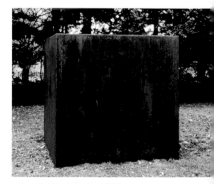

Tony Smith, Die, 1962/1968

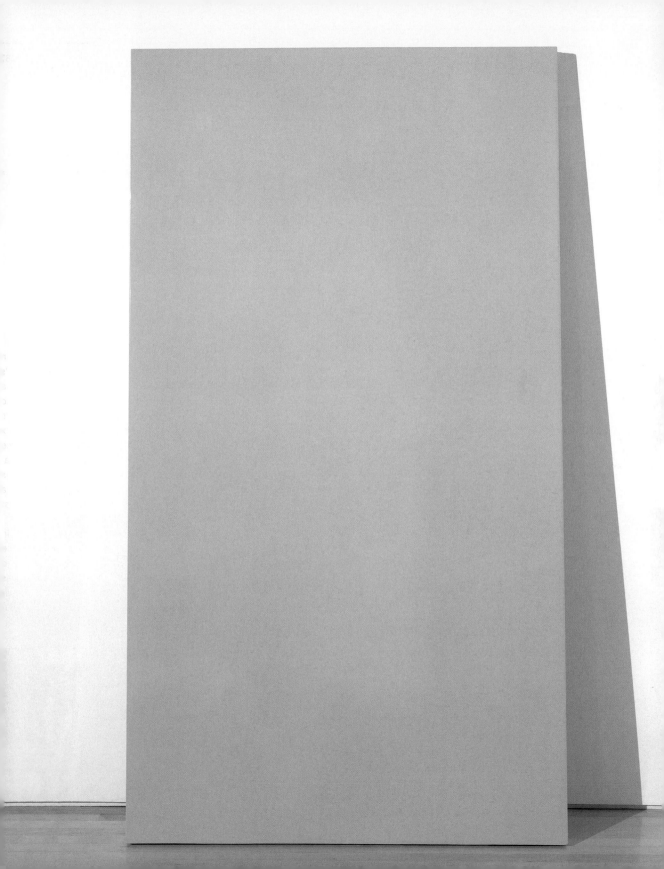

untitled

Lead relief, 55 x 60 cm
Berlin, Staatliche Museen zu Berlin – Preußischer Kulturbesitz, Nationalgalerie, Collection Marzona

b. 1931 in Kansas City (MO)

In 1960 Robert Morris moved together with the choreographers Yvonne Rainer, Simone Forti and Trisha Brown from San Francisco to New York, where they soon became central figures of the experimental Judson Dance Theater. Still within the context of the Fluxus movement, Morris started to build his first reduced sculptures in 1961. At the same time he also enrolled for the art history program at Hunter College, where he completed a Master's degree with a thesis on Constantin Brancusi in 1966. Later the same year Morris published his "Notes on Sculpture" in "Artforum" which put him on the map as a major theoretician of Minimal art. Influenced by the French philosopher Maurice Merleau-Ponty (1908–1961), he became the first Minimal artist to develop a concise theory of the reception of his work. Unlike most of the Minimal artists, Morris did not limit his work to one direction only, but explored different issues and worked in different media concurrently throughout the sixties. Coming as he does from a background of performance and dance, most of his works are concerned in one way or another with the process of making and/or perceiving.

Untitled is a wall relief reflecting Morris' early interest in the Dada and Fluxus tendencies that influenced his work of the early sixties. It also reveals his knowledge of Jasper Johns (b. 1930), who had made sculptures of flashlights and light bulbs in 1958, which, presented in an ironic, deadpan manner, influenced the development of Pop Art. The sculpt-metal Johns employed in making his objects is recalled in the colour of Morris' lead relief, and Johns' paintings/

objects, like *No* (1961), are definitely comparable. Having previous hit the wall of lead, the sound of the can suspended on the wire is no heard, but its effect is seen. In *Untitled*, a drawing from 1963, Morri uses what looks like an electrocardiogram to create simple abstrac lines in a very Minimalist composition. The zigzag lines graph th movement of a heartbeat, and like the lead relief, imply sound, which though physically absent from the work, is a part of it.

The concentric circles imply movement, time having passed; process is implied. Though lead is not a very hard surface and is eas ily dented, a ringing noise is brought visually to mind. *Untitled*'s lea surface beyond the circles is soft, suggestive of skin, and has amazin pictorial beauty. Here in the choice of materials Morris pre-figure Richard Serra's later involvement with lead, while Morris went on t work with plywood, which became his primary medium until the mic sixties.

"It is characteristic of a 'shape' that any information about it as a shape is exhausted once it is actually standing there."

Robert Morris

Hanging slab (cloud)

Painted plywood
View of installation at the exhibition "Plywood Show", Green Gallery, New York 1964

"simplicity of form is not necessarily simplicity of experience."

Robert Morris

Hanging Slab (Cloud) is one of a group of seven plywood sculptures first shown in a very important solo exhibition of Robert Morris' work held at Richard Bellamy's Green Gallery in late 1964/ early 1965. The installation became a defining moment in the history of Minimal art. The seven sculptures were arranged throughout the gallery, making full use of the exhibition space. *Boiler*, *Cloud*, *Corner Beam*, *Floor Beam*, *Table* and *Wall Slab* were placed in locations so as to fully engage the total space of the room and affect the viewer's perspective and movement. *Cloud* was seen in this exhibition suspended from the ceiling, thereby bringing the ceiling of the space into the Gestalt of the exhibition. The previous year, in a group show at the same gallery, a work very similar to *Cloud* was shown suspended five centimetres above the floor, where it was of course viewed from above. The grey, painted plywood square changed location the next year to deal more fully with the particular space of the Green Gallery.

Morris decided that *Cloud* would better serve this exhibition's goal by hanging from the ceiling parallel to the floor and thus animating the portion of the gallery space.

The title *Cloud* is a metaphorically descriptive one, alluding to its position in the upper space of the gallery, unlike the purely functionally descriptive titles of other pieces like *Untitled (Corner Beam)* which spanned two corners of the gallery, and *Untitled (Corner Piece)*, which fit into the corner, occupying it but not actually touching the walls behind it. Interestingly, to Donald Judd, who reviewed exhibitions for "Arts Magazine" at the time, the work by Morris "nearly appears to not be art". Judd found that there was not enough to look at in Morris' pieces, but acknowledged his unique use of space that seemed entirely activated. In 1964 no other artist in New York had made works of such disarming simplicity as Morris in these plywood sculptures. It was his stated goal to take all unnecessary internal relationships out of the sculpture and to shift the focus to the space and to the viewers. The arrangement of the seven pieces in the Green Gallery functioned almost as choreography, directing the viewer through the space.

As the viewer looked at the works, his act of perception itself became reflexive. Though as simple as possible, Morris' structures changed their appearance according to the viewer's perspective and location in the gallery space, reminding us that, as French avantgardist Marcel Duchamp had put it, it is always the viewer who makes the picture. There might not be much to look at in a particular Morris piece, but there's a lot to be understood from his unusual approach to what the sculpture of the mid-sixties was and could be.

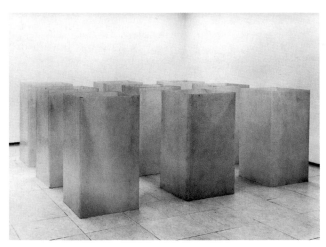

9 Fiberglass Sleeves, 1967

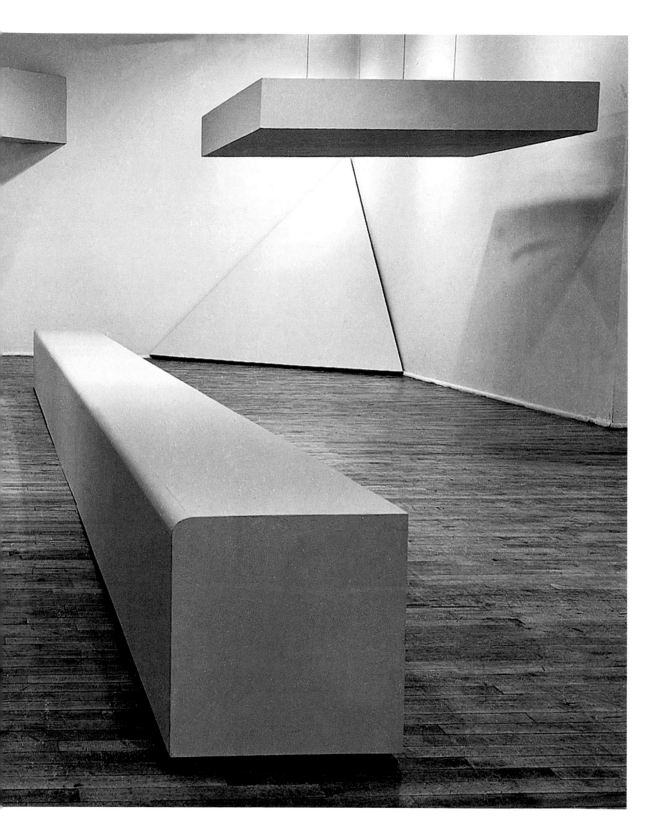

winsor 5

Oil on linen, 159.5 x 159.5 cm
Raussmüller Collection

b. 1930 in Nashville (TN)

Between 1949 and 1952 Robert Ryman studied music in his home town of Nashville. In 1952 he moved to New York in order to become a professional musician, and began to study with the jazz pianist Lenny Tristano. Ryman first encountered the New York art world through a job as an attendant at the Museum of Modern Art, where he befriended Dan Flavin, Robert Mangold, Sol LeWitt, and his future wife Lucy Lippard. In 1954 he decided to give up his career as a musician and to work exclusively as a painter. During the following ten years Ryman continued his experimental investigation of painting's foundations as an autodidact.

During his early years Ryman used mostly oil paint, which he often applied in thick brushstrokes to unstretched and unprimed canvases. His work received its first public attention in 1966, when he took part in the important "Systemic Painting" exhibition at the Guggenheim Museum in New York. Although only remotely related, Ryman's work became well known by the end of the sixties within the context of Minimal art.

Beginning in 1965, Ryman began to change from his early thick white brushstrokes and the later smooth white monochromes to paintings that began to use groupings of horizontal bands of paint that varied in thickness from painting to painting. This new systematic approach to painting was a way to further remove any pictorial or illusionist element and further the relationship of paint as paint to the surface. 33 hand-painted bands of paint roughly five centimetres wide make up the horizontal composition of this painting. The brush can be

seen as starting at the left border and traveling to the right, finishing at the edge. The dimensions of the painting's borders determine the compositional length of the bands, allowing us to see the contents of the painting as being determined by its size. Here is a variation of Frank Stella's (b. 1936) early desire to have the paint look as good on the canvas as it did in the can, or in this case the tube.

Ryman, in making groups of formally related paintings, would often use the same size of brush and same brand of oil paint for the whole group. This insured a formal, if not industrial, relationship to the painting as opposed to a personal, pictorial one. The title of the painting *Winsor 5* refers to the name of the manufacturer of the oil paint. The number 5 was used to identify this particular painting for the same reason, simply to differentiate it from others, not for formal or sequential reasons.

> **"It's not a matter of what one paints, but how one paints. It has always been the 'how' of painting that determined the work – the final product."**
>
> **Robert Ryman**

untitled

Lacquered PVC, object 34 x 34 cm, frame 50 x 50 cm
Berlin, Staatliche Museen zu Berlin – Preußischer Kulturbesitz, Nationalgalerie, Collection Marzona

Robert Ryman's works would like to make one thing clear: they are not "white pictures". If one sees them as simply white pictures or him as a painter of all-white paintings in general, one has not understood his work. When Ryman signed one of his earliest works *Untitled,* 1958, with his name and date "RRYMAN58" crawling down from the corner of the left-hand side of the painting, he announced that he was not signing or even signaling the completion of the painting, but composing it using his name and the date as elements in the painting. Other compositional elements were the choice of materials (linen or cotton duck, PVC or paper), closeness or distance from the wall or reduced palette. Few painters have explored as many materials within a clearly defined concept as Ryman has throughout his career.

The artist has adopted the square format as his preferred working shape because he is not especially interested in emphasizing a horizontal or vertical directionality within his paintings. The square is a neutral form and serves his investigations of the nature of painting. Along with Robert Mangold and Brice Marden (b. 1938), Ryman has rejected the illusionism associated with traditional painting. He prefers the painting or object to present its own physicality without any illusionist or representational value. Ryman's paintings are the visual evidence of variations on a theme, and his white is never the same. can be solid matt, or a weaving of transparent or opaque layers; either a thin veil on PVC or simply thickly painted brushstrokes on unstretched linen.

If we observe Ryman's paintings on a wall, the white square surfaces appear similar, if not identical, but looking closer, one begins to be aware that they are different. Ryman is not trying to surprise or deceive the viewer; rather his works are non-relational objects that most often exist as paint on canvas or some other carefully chosen surface. Their materiality is unequivocal; the colour white systematically applied in diverse manners, never becoming an empty exercise of formal composition.

Untitled is a thin film of PVC, which, slightly curving up at the borders, casts diaphanous shadows on its own surface. It is defined by these uneven edges as well as by the body of air separating the thin skin from the wall. The plastic film absorbs and radiates light and is an opaque surface, which invites a visual investigation on the part of the viewer.

Robert Rauschenberg, White Painting, 1951

> "ʀothko's work might have a similarity with mine in the sense they may both be kind of romantic … ɪ mean in the sense that ʀothko is not a mathematician, his work has very much to do with feeling, with sensitivity."
>
> **Robert Ryman**

untitled, from "Ten vertical constructions"

Coloured acrylic yarn
New York, Dia Art Foundation, Dia:Beacon

**b. 1943 in Bronxville (NY),
d. 2003 in New York (NY)**

After studying philosophy at Yale College, Fred Sandback received his MFA from the Yale University School of Art and Architecture in 1969. He executed his first string sculpture in 1966 and continued to explore the possibilities of this simple but extremely effective method ever after.

Sandback has the unique capacity to occupy space with nearly invisible elements. His chosen material was coloured acrylic yarn, which he employed in most of his works over the last forty years. Used with disarming simplicity to achieve the subtlest special effects, Sandback was able to create perceptual spaces within the environment of any room. He would attach the yarns to floor, wall or ceiling to achieve his effect.

The strings and wires were at times almost invisible in the shifting light of a room and could appear and re-appear as the viewer walked towards them, directing the trajectory of human movement around them. The different colours of the yarn influenced the way in which they were perceived and were an integral part of this reduced working method, but just as the body responds to the loss of any one sense, all the others are heightened.

Spaces could be defined as flat, going from wall to ceiling, or three-dimensional like triangles. Within this range of materials and methods, small decisions take on large implications. This is in accordance with Sandback's strict belief that by removing all extraneous elements from a room, the artist can direct the viewer to the desired relationship with the object, free of most other influences.

Sandback could produce any geometric and three-dimensional volume needed for a particular space. His drawings were used to plot out the works. They were highly effective in determining the geometric and volumetric outlines of the pieces, because the pencil lines perfectly corresponded to the weightless look and thickness of the actual string. Yellow coloured pencils corresponded to yellow acrylic yarn.

The works were necessarily produced in situ and each particular work always remains relative to its site. In *Small Gray Corner Piece* (1969), a vertical portion of a corner space is delineated using string and metal wires stretching vertically from the ceiling. The thinness, colour and verticality of the strings mimic the lines which define the actual corners of the room. Another unknown space is created within the space. This is an artistic and political act on the part of the artist. He declares this space to be worthy of attention, or conversely to be avoided or left alone.

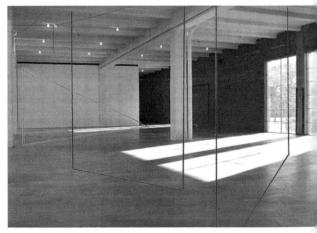

Installation drawing for Dia:Beacon, 2003

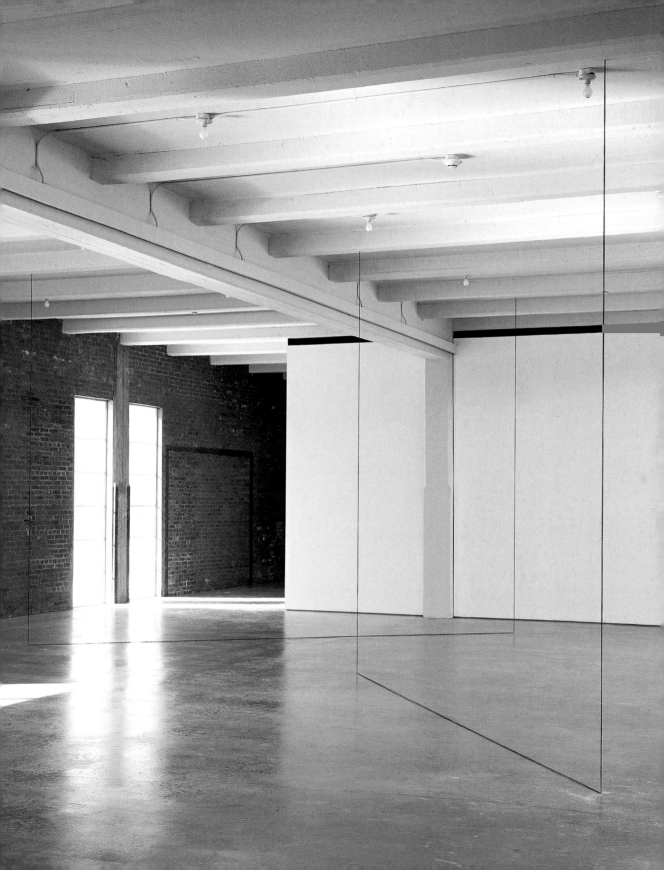

untitled

Lead, steel, 200 x 100 x 6 cm

Berlin, Staatliche Museen zu Berlin – Preußischer Kulturbesitz, Nationalgalerie, Collection Marzona

> "ɪn 1967 and 1968, ɪ wrote down a verb list as a way of applying various activities to unspecified materials. ᴛo roll, to fold, to bend, to shorten, to shave, to tear, to chip, to split, to cut, to sever … ᴛhe language structured my activities in relation to materials which had the same function as transitive verbs."
>
> **Richard Serra**

b. 1939 in San Francisco (CA)

After studying at the University of California, at Berkeley and at Santa Barbara, Richard Serra graduated in 1961 with a BA in English literature. To support himself he began working in the steel mills on the West Coast. After graduating with an MFA from Yale in 1964 he spent two years travelling in Europe. In 1966 Serra moved to New York, where he continues to live and work.

Much of Serra's work stems from the artist's direct action on a selected material to explore possibilities like transformation, deformation, loss of physical integrity or balance. His sculpture is created using common and non-precious materials, most often the Corten steel used in commercial construction, or in his early work molten lead. Lead is a heavy but soft and malleable metal relatively easy to melt, and when still in a liquid state can be scooped and thrown to harden into lead splashes or drops. In 1968 Serra began heating and throwing lead in an attempt to explore the physicality of the creative act, as well as investigate the possibilities that emerge when metal is freed from its solid state. In a famous photograph taken in the warehouse of the Leo Castelli gallery, Serra appears like a goggled Zeus throwing lead thunderbolts at walls and corners. The resultant lead forms were both the physical evidence of his act and its sculptural surrogate.

Serra also used lead plates and sheets, which he rolled into irregular pipe forms. He combined these forms in pieces like *Prop* (1968), which uses rolled lead as a prop to suspend a lead sheet precariously against a wall, or *Plate, Pole, Prop* (1969–1983), which instead employs hot rolled steel to hold massive steel plates to the wall. In the film *Hand Catching Lead* (1968), he is filmed repeatedly trying to catch a piece of lead falling from above, further emphasizing the effects of gravity and tension.

Untitled is a rectangular plate of lead laid out on the floor. Its surface appears soft and undulating. Across the middle of it is a thin steel cable attached to each side. The tightening of the cable fastener in the centre pulls the thick grey skin of the lead surface up at the two points, creating a visible tension on the cable and on the surface of the piece. The effect is surreal because of the heavy skin of the lead mass pulled up in this manner. The cable fastener represents the potential for further transformation of the sculpture's surface and the ongoing process involved. This consciousness is part of the work.

Splashing, 1968

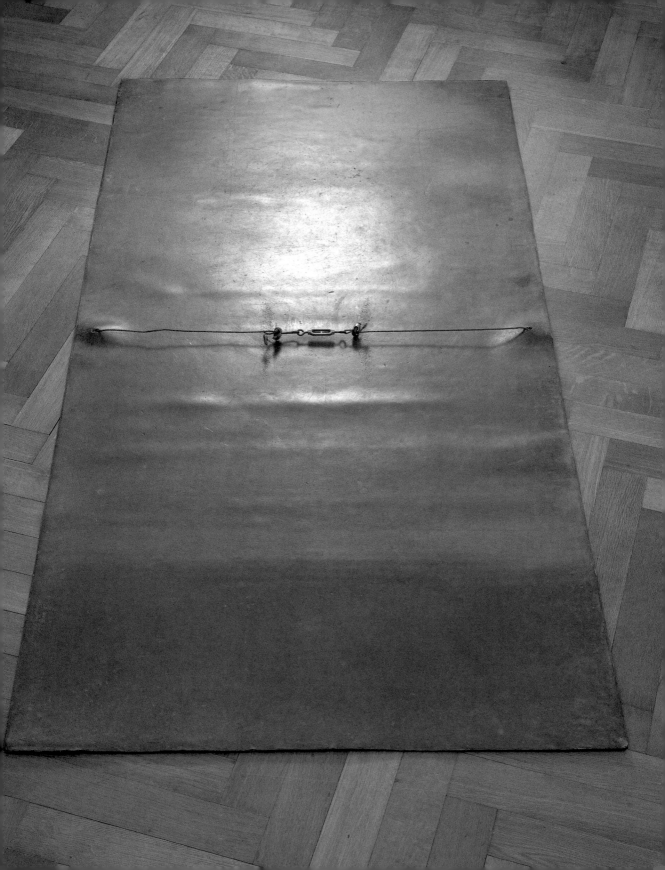

one ton prop (House of cards)

Lead antimony, 4 plates, each 122 x 122 x 2.5 cm
New York, The Museum of Modern Art, Gift of the Grinstein Family, Acc. No. 286.1986.a–d

Richard Serra's continued use of plates led to *One Ton Prop (House of Cards)*. Here instead of a rolled lead pipe propping up a piece of lead against the wall, four plates use their own heavy weight to hold each other up in a house of lead cards. The rough-hewn irregular edges display a disregard for preciousness, or worse, "finish". Process is implied by the energy used to cut the thick, unwieldy lead and to put the piece together. There is also the element of danger present if the house of cards were to fall. This precarious quality became an increasingly important element of Serra's work.

In *Tilted Arc* (1981) and the *Torqued Ellipses* (1997), the public could walk around and through these gigantic works of Corten steel and feel at certain points that the work was going to come down on top of them. Looking up one could see apertures of light, but no direction. In the case of *Tilted Arc*, these qualities of the sculpture caused a public controversy that was unprecedented in the United States. Many city workers who entered the building daily felt offended by the austerity and massiveness of the sculpture and began to complain soon after its installation. A long process of public hearings and petitions finally led to its removal from the Federal Plaza in lower Manhattan.

Here the viewer is taller than the 120-cm plates and can walk around it, taking care not to upset the piece. In the later pieces such as *Torqued Ellipses*, the viewer is completely surrounded and at the mercy of the artist and the skill of the fabricator. In even later pieces such as *Consequence* (2003), installed at the Dia Art Foundation in Beacon, NY, the viewer walks down a long gap between the two sides created by the artist. Perspective in this work is manipulated. The visual disorientation the viewer feels corresponds to Bruce Nauman's (b. 1949) *Performance Corridor* made the same year as *One Ton Prop*. Nauman wanted the viewer to be able to experience and view the same action he had earlier performed (and recorded for a video performance) within the piece. In both cases the viewer can participate without altering the work.

Serra's recent work, done in weatherproof steel, has developed an almost baroque quality, whereby the properties of sculpture which initially inspired him have mutated to create works which display unimaginable feats of conception and fabrication. In these works Serra has pushed his aesthetic to the limit, executing every thought and whim with utmost clarity and skill. In *Vice-Versa* (2003) two rectangular sheets of steel unfurl in weightless motion, their bulk form immaterial in aesthetic terms. The five furling forms of *Wake* (2003) continue this tendency. In *Blindspot*, also done the same year, the curls of steel appear as metal shavings that, if followed to the centre lead the viewer to a blind spot. The spectator is still dwarfed by the work, but his relationship is more stable, as is the work itself.

"I wanted a dialectic between one's perception of the place in totality and one's own relation to the field as walked. The result is a way of measuring oneself against the indeterminacy of the land. I am not interested in looking at sculpture which is solely defined by its internal relationships."

Richard Serra

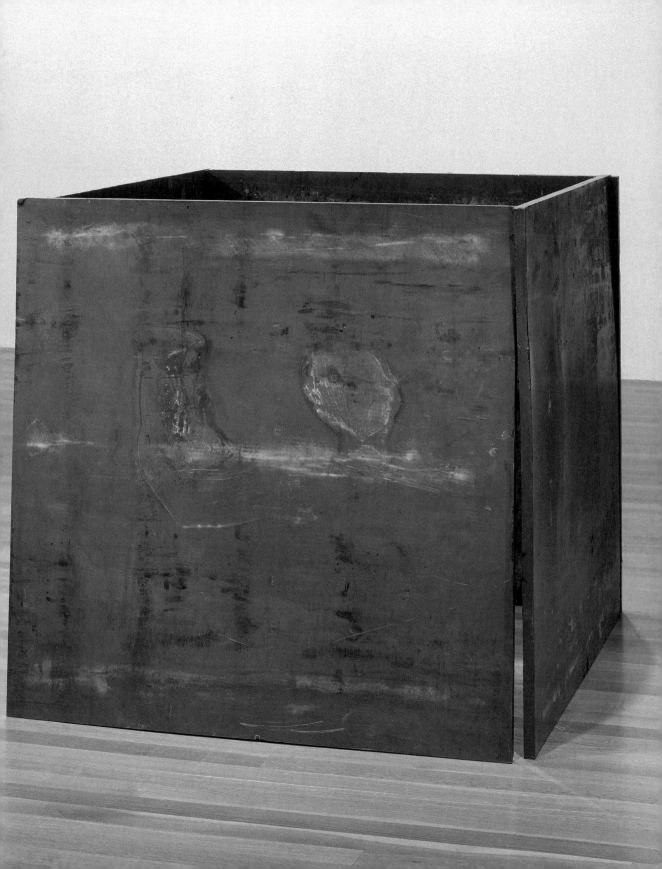

Free Ride

Painted steel, 203 x 203 x 203 cm
New York, The Museum of Modern Art, Gift of Agnes Gund and purchase

> **"we think in two dimensions –
> horizontally and vertically –
> any angle off that is very hard
> to remember;
> for that reason ı make models –
> drawings would be impossible."**

Tony Smith

**b. 1912 in South Orange (NJ),
d. 1980 in New York (NY)**

Tony Smith has always insisted that his art was "not a product of conscious calculation, but prompted by the enigmas and tumult of the unconscious. All my sculpture is on the edge of dreams." Thus Smith's work of the early sixties represented an important link between the Abstract Expressionists' ethos and the new attitude towards the making and meaning of art in the sixties. Smith continued the Expressionists' beliefs in subjectivity, but at the same time also functioned as a reference for younger artists such as Sol LeWitt, Donald Judd or Robert Morris, whose Minimal objects resembled his geometries. Only in retrospect can the systemic methods and concepts of the younger generation be clearly distinguished from Smith's narrative and sometimes theatrical approach to sculpture.

Free Ride, created in 1962, the same year as *Die*, continues Smith's systematic approach to sculpture. Each painted steel unit is 203 centimetres in length, thus insuring a visual continuity of mathematical logic tempered by Smith's post-expressionist feel for association and content. There is a logical arrangement of forms that is both geometric and natural. The sculpture snakes along the floor in three units. The vertical rectangular form could be placed down on its side and look like the same piece from a different angle – the freedom of modular forms that would resonate throughout the sixties. The black simplicity of *Free Ride* distances it from the influence of David Smith (1906–1965), whose work at that time was highly important. Tony Smith removes David Smith's burnished, Expressionist surfaces and post-Cubist references to the human body and replaces it with an impersonal, sleek, black surface devoid of painterly references. Smith also, unlike David Smith and others of the preceding generation, adds a critical distance by having *Free Ride* commercially fabricated as opposed to being welded by the artist himself.

The Elevens Are Up, 1963, *Die* and *Free Ride* all have in common that their separate units are all of equal length – another element of the modular, impersonal construction so characteristic of Smith's work and which contributed to his proto-Minimalist credentials. Here is the point of entry for sculptors like LeWitt and Morris, who could and would make entire exhibitions based on one or two simple forms responding to their already artificial gallery environment. Smith created sculpture that dealt more effectively with the modern architecture of buildings and the galleries housed in them and thereby destroyed the pedestal once and for all. The floor itself was all Smith and the Minimalists would need.

One can view the work as an objective, three-dimensional form or as a subjective experience. Smith would have allowed both, since he believed that any object seen by any viewer could be interpreted differently based on a variety of outside factors.

Smith, as a trained New Bauhaus architect, had a strong interest in architectural forms, geometry, and its relationship to nature. He was particularly interested in the cube and the tetrahedron. Smith would build cardboard models to determine the forms of his sculptures and to find the proper, dynamic relationship between them.

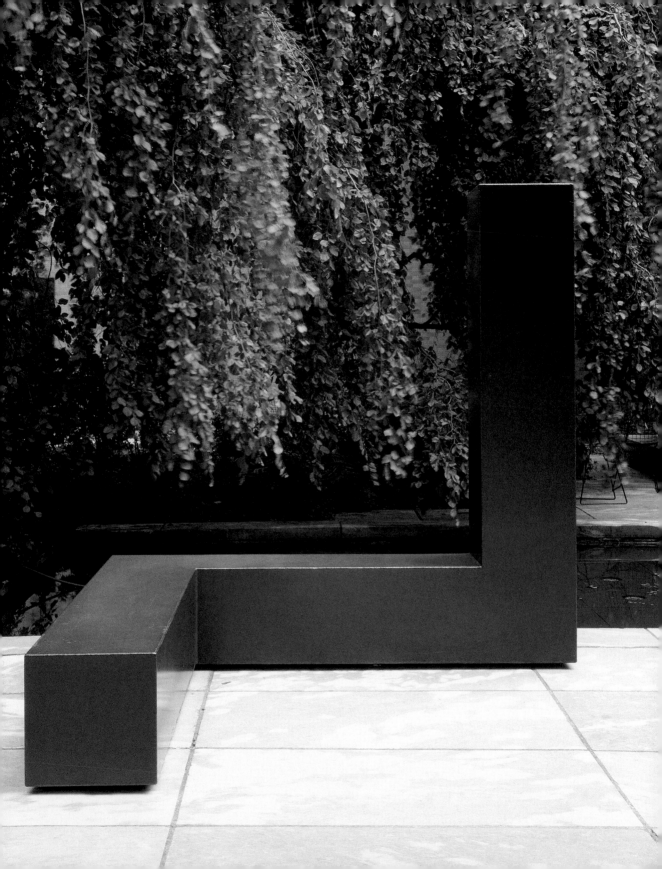

Mirage NO. 1

Mirrored glass, 9 parts, 92.4 x 648.7 cm overall
Los Angeles, The Museum of Contemporary Art, purchased with funds provided by the Collectors Committee 94.15A-

**b. 1938 in Passaic (NJ),
d. 1973 in Tecovas Lake (TX)**

Robert Smithson was one of the most prolific artist-writers of his time. He wrote extensively on the work of his contemporaries as well as on his own ideas about art. Smithson's early abstract sculptures were based on crystalline forms and therefore only remotely related to the non-referential objects of most Minimalists living in New York. As early as 1966 Smithson had announced the destruction of the Minimal object in his famous essay "Entropy and the New Monuments". Later he developed an artistic strategy combining different media and different forms of presentation, which has been considered by many scholars as the beginning of a postmodern art practice. He was expanding the role of what the artist could do within his own specific body of work, allowing his various interests to decide the parameters of what constituted an artist's oeuvre.

Mirage No. 1 consists of nine framed mirrors increasing or decreasing in size, depending on your perspective, from one foot to one yard (30.5 to 91.5 cm) in three-inch (7.6 cm) increments. They are all hung from left to right exactly one inch (2.54 cm) above the floor and reflect the space in which they are hung. The serial order of the mirrors breaks up the reflected space, effectively displacing the viewer and literally breaking up his perception of the room and himself. This concern with visual perception was a lifelong interest of Smithson, who noted its equivalent in nature and used its contradictions as the subject of his work.

Smithson's 1966 essay "Entropy and the New Monuments" dealt with the Second Law of Thermodynamics, which reveals the universal tendency towards disorder. Smithson felt that since "energy more lost than obtained", he would exploit this tendency within natur He wanted to remove his work from the casually organic form of old materials like marble or granite, to the "new" materials of "plast chrome and electric light". In *Mirage No. 1* Smithson imposed a mod lar, serial view of nature within a modern, geometric form of rectang lar, mirrored glass.

This work looks forward to Smithson's "Mirror Displacement (1969/70), which located the mirrors outdoors to reflect nature ar combine the hard and new materials with the found and the organ Smithson also began with these mirror reflections to refer to objec outside the space, leading to his "Nonsites" begun in 1968. Th "Nonsites" were the accumulated rocks of his explorations found ou side the gallery space, which were brought in and documented wi maps explaining their locations in nature. These were followed by h gravitational "Pours" and his last earthworks, like the *Spiral Jet* (1970) in the Great Salt Lake in Utah.

Smithson, like other people of his generation, had a stror interest in beat poetry, cinema, and science fiction, which is why som of his drawings resemble the science-fiction comics of the late fiftie The nine pieces of *Mirage No. 1* reflect this in a cinematic, frame-b frame progression of image and time, the image itself made of th reflection of what is in front of it. The mirrors also use the wall the wa Carl Andre would use the floor in a serial progression of "mirrore plates", but here throwing the reflection of the floor up onto the wa and revealing what would in effect be covered by an Andre piec Even here Smithson can be seen to be making "new monuments" o "new materials".

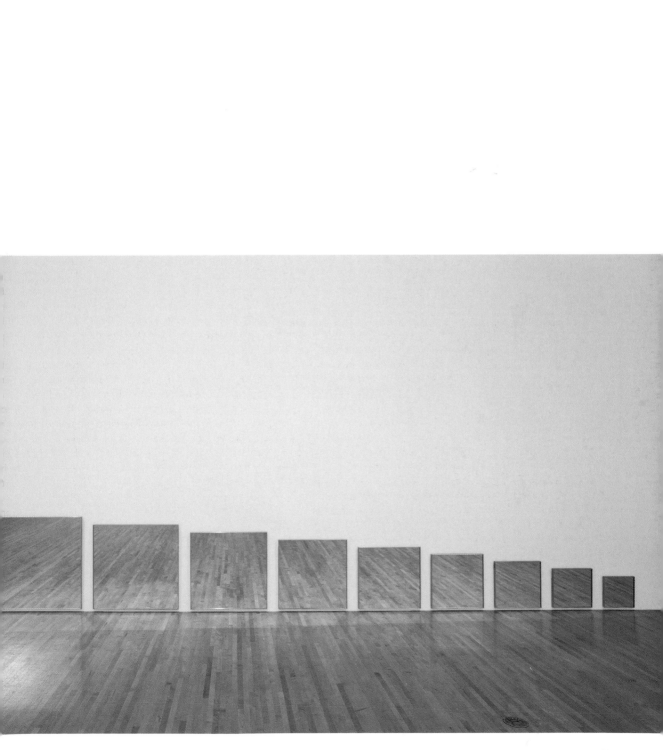

кnight's нeritage

Wood and acrylic paint, 154 x 154 x 30 cm
Courtesy of Danese Gallery, New York

b. 1921 in Baltimore (MD),
d. 2004 in Washington (DC)

Soon after Anne Truitt had completed her degree in psychology at Bryn Mawr College in 1943, she moved to Boston where she enrolled in evening sculpture classes and began to write poetry. Throughout the forties and fifties Truitt worked in different media and styles, focusing in particular on ink drawings.

She developed her mature sculptural work around 1961 when she established her first studio in Washington. In the spring of 1963 Truitt had her first solo exhibition at the André Emmerich Gallery, New York, which was viewed as a very successful debut. While Donald Judd reviewed the show negatively, Clement Greenberg, who helped install the exhibition, praised the quality of Truitt's work throughout the sixties.

Reduced forms and simplified colour combinations are seen in *Knight's Heritage*, one of the block-like forms Truitt made, signalling a change in her work from more overt figurative or referential sculptures like *Green Five*, which was made only a year or so earlier. To use an architectural metaphor, this piece is more an apartment block than a skyscraper. The square block appears proportioned differently, not quite a square or a rectangle, a result of the abstract progression of mars orange, yellow and black painted on the surface. The last black section is much thinner than the other two and gives direction and movement to the piece as well. It is representative of the larger, heavier forms that stand directly on the floor with no pedestal and remove the earlier references to tombstones and picket fences. They instead have a more internalized reference to the world.

The title *Knight's Heritage* is suggestive and personal, something that sets Truitt apart from her Minimalist colleagues who preferred to leave their works numbered or untitled. Also different is the rationale for her sculpture. She attempted to reflect states of mind, memory, hers and the viewers', in abstract form. Any form in various colour combinations will suggest different things to different people. Truitt allows this to work as an important element of the sculpture, which is why she has named her works after people, places, numbers or things.

One (1962) has a ghostly, singular presence that is at once "sixties" (though less Minimalist because of its base-like form), but also perhaps ancient. Its simple, stark appearance has a resemblance to Cycladic Greek art; a white alabaster abstract figure seen standing both head and arms down. The light that falls on it can be called "tragic", a quality she understood from the paintings of Barnett Newman (1905–1970), whose work she greatly admired.

> **"what ı want is colour in three dimensions, colour set free to a point where, theoretically, the support should dissolve into pure colour."**
>
> **Anne Truitt**

celebrate!

"Something new to be learnt on every page."
— *The Tablet*

"A fascinating and valuable resource book."
— *Catholic Herald*

"A necessity in any reference collection. It makes compulsive reading and is packed with detail."
— *The School Librarian*

RELATED TITLES PUBLISHED BY ONEWORLD

God's Big Book of Virtues, compiled by Juliet Mabey, ISBN 1–85168–171–X
God's Big Instruction Book, compiled by Juliet Mabey, ISBN 1–85168–170–1
The Oneworld Book of Prayer, compiled by Juliet Mabey, ISBN
 1–85168–203–1
Jesus the Son of Man, Kahlil Gibran, ISBN 1–85168–183–3
Life After Death, Farnáz Ma'sumián, ISBN 1–85168–074–8
The Meaning of Life in the World Religions, edited by Joseph Runzo and Nancy
 M. Martin, ISBN 1–85168–200–7
The Phenomenon of Religion, Moojan Momen, ISBN 1–85168–161–2
Words to Comfort, Words to Heal, compiled by Juliet Mabey, ISBN
 1–85168–154–X

celebrate!

A LOOK AT CALENDARS AND THE WAYS WE CELEBRATE

margo westrheim

ONEWORLD

OXFORD

CELEBRATE!

Oneworld Publications
(Sales and Editorial)
185 Banbury Road
Oxford OX2 7AR
England
http://www.oneworld-publications.com

Oneworld Publications
(US Marketing Office)
160 N. Washington St.
4th floor, Boston
USA

© Margo Westrheim 1993, 1999

ISBN 1–85168–199–X

Cover design by Design Deluxe, Bath
Printed and bound in Hong Kong by Imago